The Remembered Present

The Remembered Present
Andrzej Jackowski

black dog
publishing
london uk

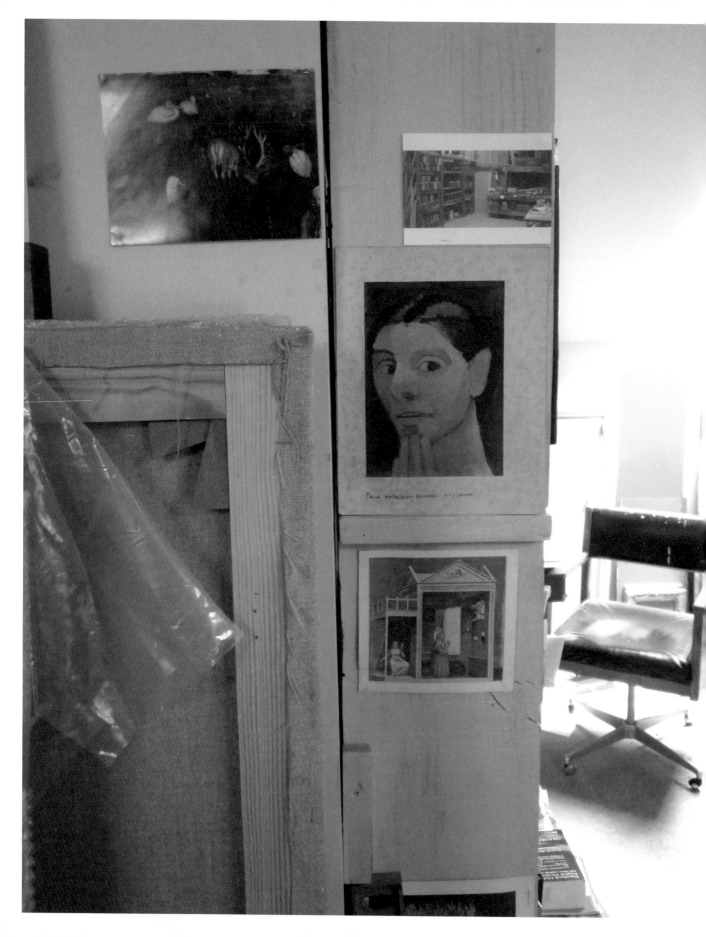

6 **Albums & Aliens**
Andrzej Jackowski

8 **Retrieving a New Poetics
of Space, 1980–1990**
Timothy Hyman

44 **Stored**
Andrzej Jackowski

46 **Reveries of Dispossession**
Gabriel Josipovici

86 **A Space in the Dark**
Andrzej Jackowski

88 **Powerful Now, Like Legends**
Michael Tucker

144 **The Pine Tree by the Sea**
Andrzej Jackowski

146 **End Matter**
*Notes, Works, Biography,
Contributors and Acknowledgements*

Albums & Aliens
Andrzej Jackowski

My grandfather on my father's side traded in pigs across the
Austro-Hungarian Empire.

My grandfather on my mother's side ran a horse riding school
in Warsaw.

My grandmothers as far as I know stayed at home.

My father thought about being a teacher but in the end he joined
the resistance to the Austrian and Russian occupation, later he
joined the proper army being wounded three times and winning
a number of medals. He spent the Second World War near Lake
Balaton in Hungary, where he started to collect Hungarian stamps.
By the end of the war he had five volumes. He took these with him
when he walked across the Alps to Italy, where he joined the Red
Cross at Monte Cassino.

My father was married four times—my mother was his third wife.

My father was my mother's second husband. Her first husband, who
was a correspondent for a Polish radio station, died on the Russian Front.

My mother, after travelling through Romania, Italy and France spent
the war with a Polish community in Algiers. At the end of the war
she joined the Red Cross at Monte Cassino—where she met my father.

In 1946 they had a choice to sail to New York or to Liverpool.

I was born in a Polish hospital in North Wales. For the next 11 years,
the three of us lived in a camp for refugees near Crewe.

The huts in the camp were made of wood and covered in tar.

My parents carried a card saying they were aliens.

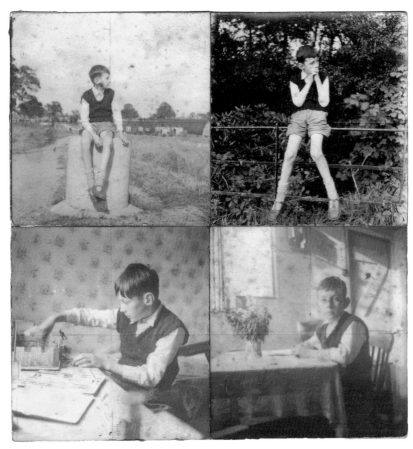

**Photographs in Doddington Camp of Jackowski,
c.1956, collected in a sourcebook.**

One of my first memories is of being at a table and turning black
pages of the stamp albums, with glowing images of cities, trees,
animals, mountains, airplanes, and people.

Some years later my half-sister who had been left in Poland when
my father escaped to Hungary, came to visit. My father gave her
the albums.

She took them on a boat to Poland.

When I was 11 years old we moved to London and lived for a while
with my half-brother who was a photographer. When I was about 14
my parents separated. About the same time I painted a self-portrait,
and made a decision to become a painter.

Retrieving a New Poetics of Space, 1980–1990
Timothy Hyman

In Jackowski's key early picture of 1980, *The Tower of Copernicus*, the human figure needed to disappear before the true subject—the emptied spatial enclosure itself—became evident. That cusp of the 1970s and 80s was a hopeful moment for Jackowski's generation, when many previously marginalised painters seemed suddenly to find their voice. But how does one rebuild the image after a demolition? Could pictorial space, for so long suppressed in the flattened and impoverished formalism of the 1970s, once again be recovered at full strength? Some of the problems that surfaced in Jackowski's early development still haunt the project of painting in 2009. For example, if we are to evade academic figuration, we may need at some point to 'de-skill'—to approach the condition of the child and outsider. Yet eventually our pictorial language must also come to terms with the complexity of painting's history, its nuanced richness of reference and association.

A Prelude: 1963–1973

Jackowski's Polish parents met in the Red Cross at the battle of Monte Cassino, arriving in Britain in the aftermath of war. In 1947, he tells us, "I was born in a Polish hospital in North Wales. For the next 11 years, the three of us lived in a camp for refugees near Crewe. The huts in the camp were made of wood covered in tar."[1]

Throughout those years in the camp, Jackowski's first and main language was Polish. The sense of being an alien, an exile, displaced from a lost nation—a land of forest, snow and Baltic shore— permeated the child's consciousness. Eventually the family came to west London. The boy enrolled at Holland Park Comprehensive, where his work in the art room or beyond first became of absorbing interest. But this activity was always bound up with a personal quest, for some image of wholeness, beyond all loss and fragmentation. "When I was about 14, my parents separated—about the same time, I painted a self-portrait, and made a decision to become a painter."[2]

Just enough survives to plot a development. Several emphatic little images made in soft pencil as a 16 year old schoolboy show an exceptional graphic confidence. A football stadium in reddish pastel reveals a gift for creating atmospheric space. Two grey gouaches represent his foundation year at Camberwell School of Art—a strict, life room centred regime; "drawing an egg for a week, that kind of thing".[3] Under Euan Uglow he measured in the approved "Camberwell dot-and-carry" manner, a drawing-system he would later struggle

Jackowski's early school drawing from Holland Park School, 1963.

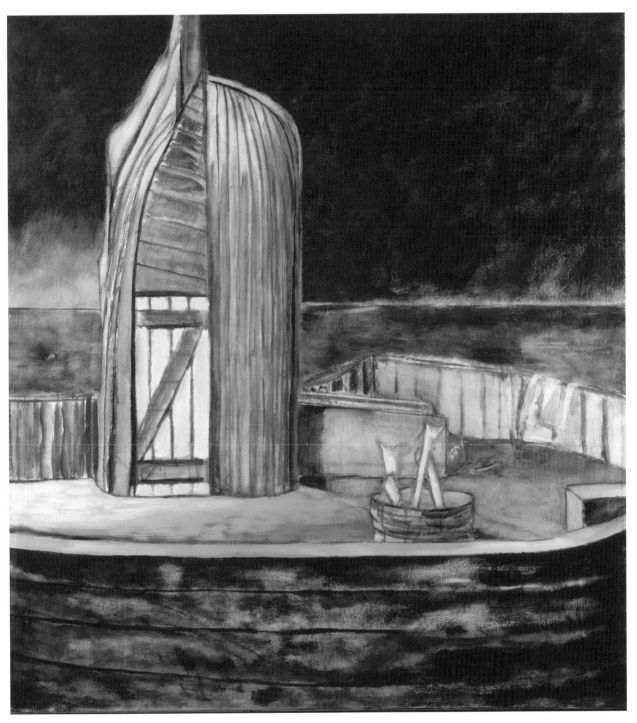

The Wooden Vessel 1983

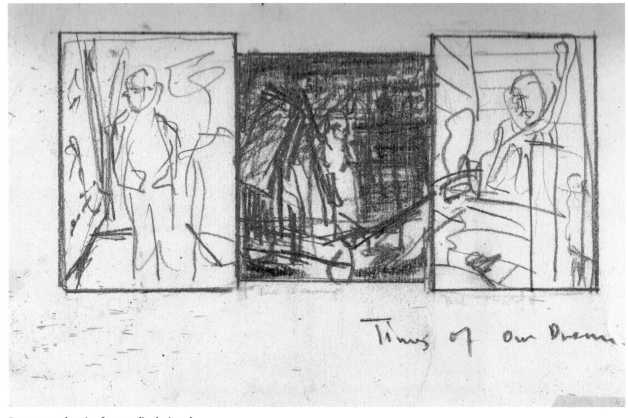

**Preparatory drawing for unrealised triptych,
from a sourcebook c. 1981.**

to un-learn. His passing on to Falmouth School of Art, in 1967, coincided with the apogee in British art schools of American colour-field painting. "There was this feeling that you were not allowed to tell stories in painting. There was abstraction and only abstraction."[4] Thwarted, he began in his second year to make films: "very simple… little things happening, the camera panning round, discovering objects in the half-light…."[5] But he wasn't painting, and, understandably, he was asked to leave the course. He had already met his first wife, the poet Nicki Jackowska. Together, they moved to Zennor, where he worked on a farm. "It was a pretty depressing time."[6] Nevertheless, these Cornish years—from which few drawings survive—were crucial to his formation. "When I got chucked out of art school, I had to really think through: 'why do images'?"[7] At Falmouth one mentor was the poet Peter Redgrove; Jackowski came to recognise that "poetry was a way of getting at your self: one of the ladders for getting inside".[8] Shouldn't painting also be "a way of getting at your self?" Visiting London in Autumn 1971, he saw the Tantra exhibition at the Hayward Gallery. In Tantric art, image-making, sexuality and healing were all indissolubly entwined; for Jackowski, it opened up a project of "meditating on images as a way of knowledge".

Up to this point, Jackowski had preserved "an anti-intellectual attitude towards art".[9] Admiring the directness of child art, and also partly "to break the Camberwell thing", he had been drawing for several years only with his left hand.[10] Even when he began to work more purposively, first back at Falmouth, then at the Royal College of Art, his idiom was still close to child art. A sequence of etchings and watercolours made over a two-year period plays on the figure-in-an-enclosure: Beast, or Naked Girl, framed in the rectangle of Window, Door, or Bed. In *Room with a View*, the grey woman is splayed against the red fields of bed and carpet; the view, as becomes explicit a year later, is that of ourselves as voyeur, gazing in at her nakedness. Seeing an exhibition of Howard Hodgkin at Oxford (and, later, meeting him at the Royal College) helped deepen this language of brightly patterned but inhabited compartments. Jackowski's handling became richer, and more impassioned, with the woman now scrawled in bitumen-black. It was a large, oil-painted variant of this composition that would be selected for the 1976 John Moores exhibition—Jackowski's first serious public showing.

Room with a View 1975

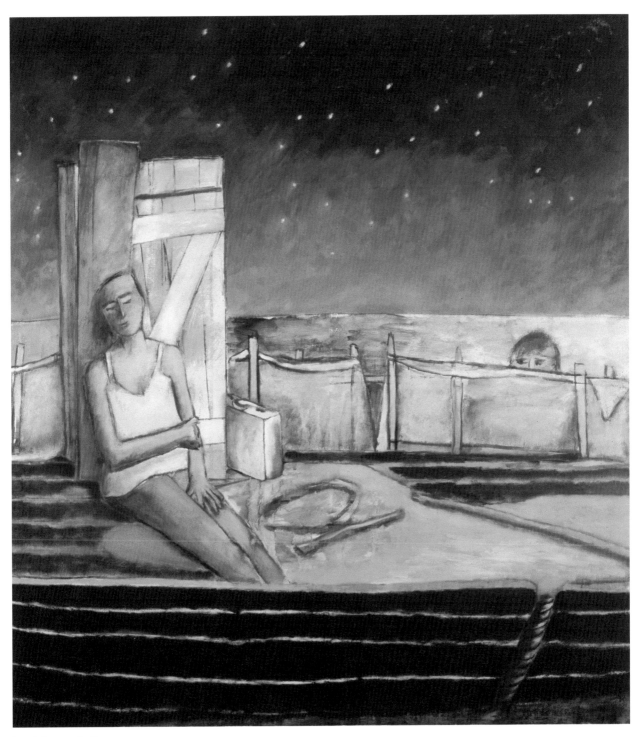

Love's Journey I 1983

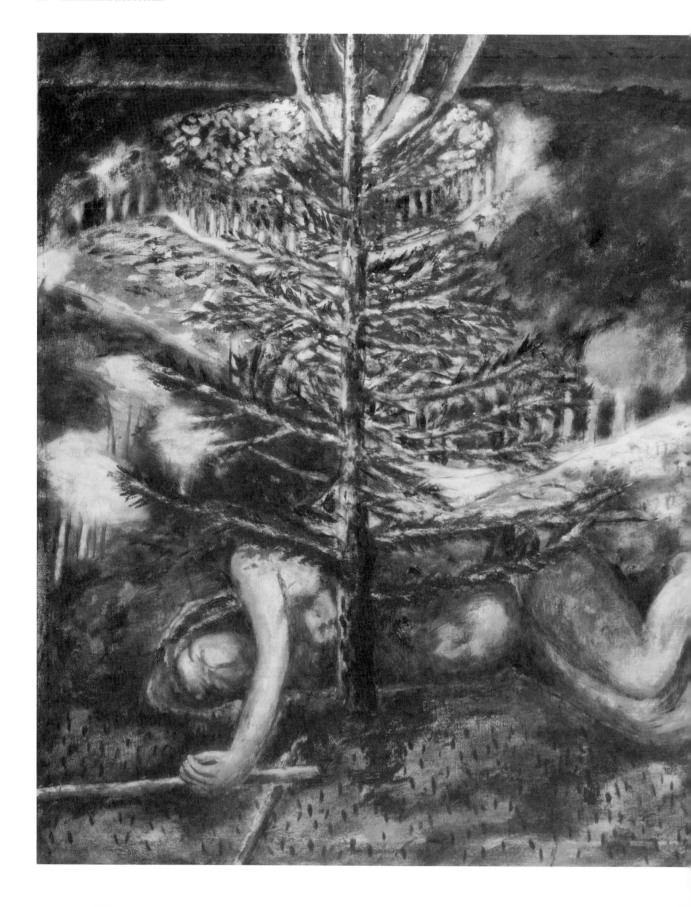

The Fir Tree 1983

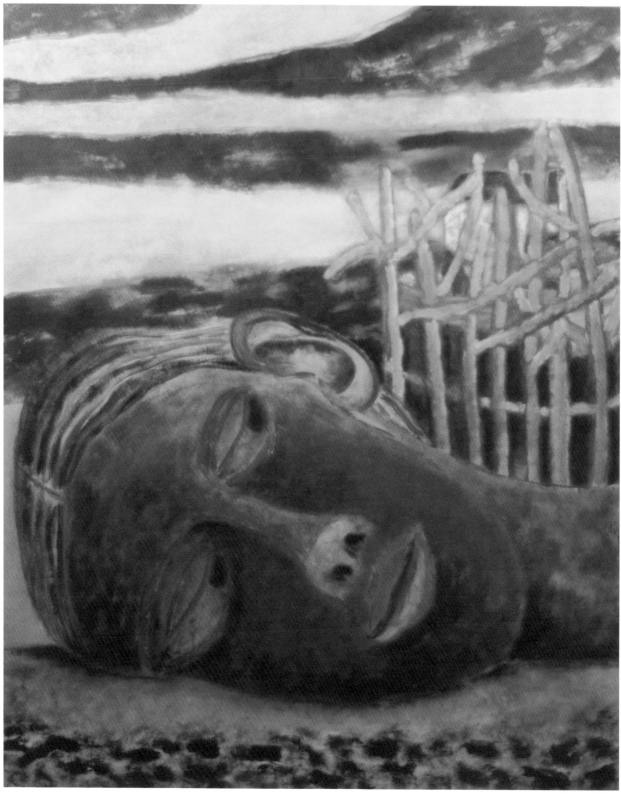

The Vigilant Dreamer II 1985

Vigilant Dreaming

Meanwhile, at the Royal College, he had encountered a range of sympathetic yet essentially analytical teachers, including Peter de Francia, RB Kitaj, and Philip Rawson, the curator of the Tantra exhibition.[11] By the time Jackowski made the journey to Lausanne, to see Dubuffet's Art Brut collection, he'd begun to question the validity of this aesthetic of autism. Dubuffet had written of "an irreducible antagonism between the creation of art and a desire to communicate with the world".[12] Yet Jackowski had travelled on to Italy, seeing Giotto's Arena Chapel in Padua; and in Paris on the way back, stumbling across some pictures by Balthus.

Both Giotto and Balthus seemed to re-open the possibility of art as 'communication', above all in their creation of pictorial space. Back in London he read Gaston Bachelard's *The Poetics of Space*. "I got very excited… because it was to do with reverie. He talks about an album of images… they're to do with certain spaces: drawers, nests, forgotten corners under the table… an essential poetic vocabulary."[13]

At last he could see a way in which inner and outer could be fused. He began to use his right hand again, drawing directly from people, objects, places. *The Visit* presents a real room: table, chair, fireplace, mirror, and the two figures, imbedded within them. Yet what appears to be an open door behind them turns out to signal a very specific reference; it is the left segment of Carlo Carrà's iconic landscape of 1921, *The Pine Tree by the Sea*. Carrà's own re-discovery of pictorial space, after the fragmentation of Futurism, was reached via 'Douanier' Rousseau and Giotto. It paralleled Jackowski's journey; he loved "the mood of thinking" Carrà's images create.[14] Within a reconstructed space, wrested from the void, reverie could flower. He saw that "painting has a stillness, an ability to plunge vertically—you can let time unfold and bloom".[15]

This recovery of the real, the specific, meant his range of subject-matter could now be vastly expanded. His daughter Laura: the dark waters of a pier at night, an armchair; or the steep terraces of the surrounding Brighton streets—all could now provide material for his pencil. Suddenly he was linked to a generation (as yet mostly un-exhibited) who were making a similar voyage of rediscovery.

He had begun to collect in albums found images cut from magazines. Sometimes, almost magically, these separate sources might coalesce into a single more resonant image, linking to his wider thought. As a reader, Jackowski was also fired-up by what might be called 'found phrases'—such as, from Bachelard "intimate

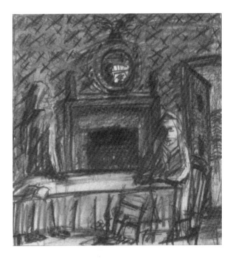

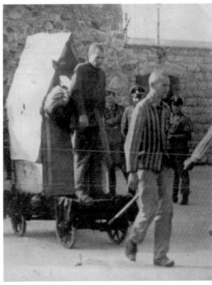

Top **The Visit** 1977
Bottom **Photograph from a magazine found c. 1979, collected in a sourcebook.**

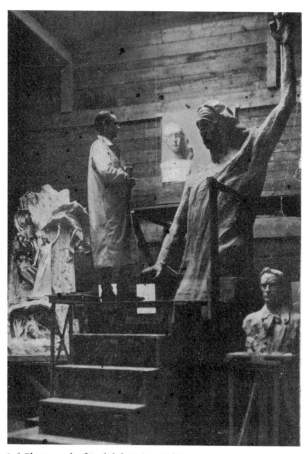
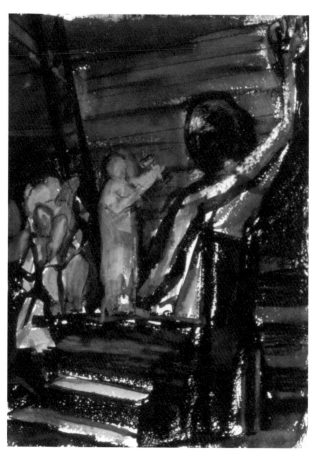

Left **Photograph of Rudolph Steiner in his
studio, taken from a magazine, collected in a
sourcebook c. 1979.**
Right **Rudolph Steiner** 1979

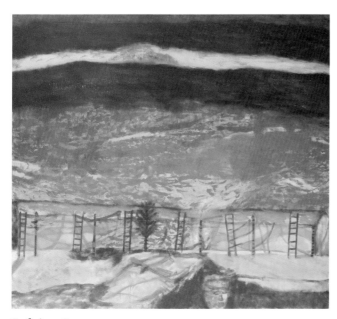

Surfacing 1987

immensity"; or, from Rudoph Steiner, "vigilant dreaming"—
phrases that would leap out at him and provide energy for his work.
He registered a special interest in magus-like figures, often from
Eastern Europe. The performances of Tadeusz Kantor exercised a
powerful spell; assembling props on stage and speaking through
them, the objects emanating a life of their own. In *The Dead Class*,
1976, Kantor opened a dialogue with the pre-war Polish-Jewish writer
and draughtsman Bruno Schultz, invoking a crossing to some inner
realm, some core of being: in Schultz's phrase, the place "where
the stories come from". Jackowski wrote to me in 1979, "I feel the
only way to 'capture' those kinds of intimate moments… is to set
traps. To construct 'vessels' to contain them. To build an ark out of
furniture and prams and tables and, most important, people…."[16]
A series of magus-portraits would have included *Dr. Grodeck in his
Clinic in Baden-Baden*, and *Rudolph Steiner at Dornach*, with the founder
of anthroposophy sculpting a figure of Christ.[17] Steiner's emphasis
on wood as a material of sacred construction linked to Jackowski's
childhood in the wooden world of the camp; the dark head is set
against the slant of the planks. Not only the compelling space, but
the smouldering reddish-black colour, the nocturnal mood, as
well as the energy of the marks—all announce that in this image
Jackowski has indeed arrived at the core.

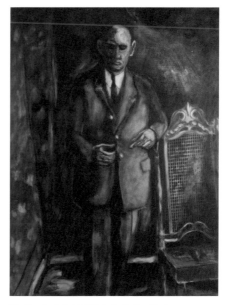

Dr. Grodeck in his Clinic in Baden-Baden 1979

At the Lining of Things:
The Tower of Copernicus, 1980–1990

Give me your hand, take another step: we are at the roots
now… on the nether side, at the lining of things, in gloom
stitched with phosphorescence….

Bruno Schultz, *The Sanatorium under the Sign of the Hour Glass*, 1937

Every thing now converged upon a single decisive image. Reading
about the Polish astronomer-monk Copernicus (in Koestler's *The
Sleepwalkers*) he imagined him "in his tower, living there on the Baltic
Sea for 30 years with an open view of the stars at night".[18] And this
in turn "reminded me of lying in bed as a child and trying to work
out how the universe came to be, and why and when and if it would
end".[19] He had seen photos of the actual rooms where Copernicus
worked (the walls still covered with geometrical diagrams). Yet if he
was to conjure again those childhood thoughts—"those awesome
black hole kind of thoughts which one can suddenly tumble down
into"—he needed also to reconstruct the space in which they
occurred.[20] And the space-of-childhood turned out to be very
specific: "a wooden barracks covered with tar, with the inner doors
made out of blankets".[21]

Jackowski had sought for his art a special balance of outer and
inner, "turning the inner life out, as in a coat, and the outer life in".[22]
Suddenly the literal 'lining' of his childhood environment, the slatted
wooden architecture, provided a metaphor, a release. He painted
The Tower of Copernicus in three weeks, sending it almost immediately
off to an open competition (the Tolly Cobbold); where it won a
prize, and was promptly purchased for the Arts Council Collection.
Originally the focus was to have been Copernicus himself; another
Grodeck or Steiner. But the figure became, in a sense, redundant. The
various objects in the room—the wheeled hut, the ladder, as well
as the glittering-eyed cat-familiar—sufficiently conjured the absent
magus. Or, to put it another way, spatial enclosure became in itself the
material of reverie. The tower is felt as a kind of alchemical kitchen,
already half-way to the stars, set apart from the everyday world, and
joined to it only by a ladder.

He had come across the wheeled hut in a concentration camp
photograph. In the earliest pencil-study, the vertical stripes of the
inmates' uniform are set against the horizontal slats. The strange

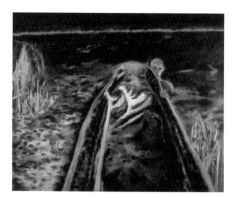

Diving into the wreck 1983

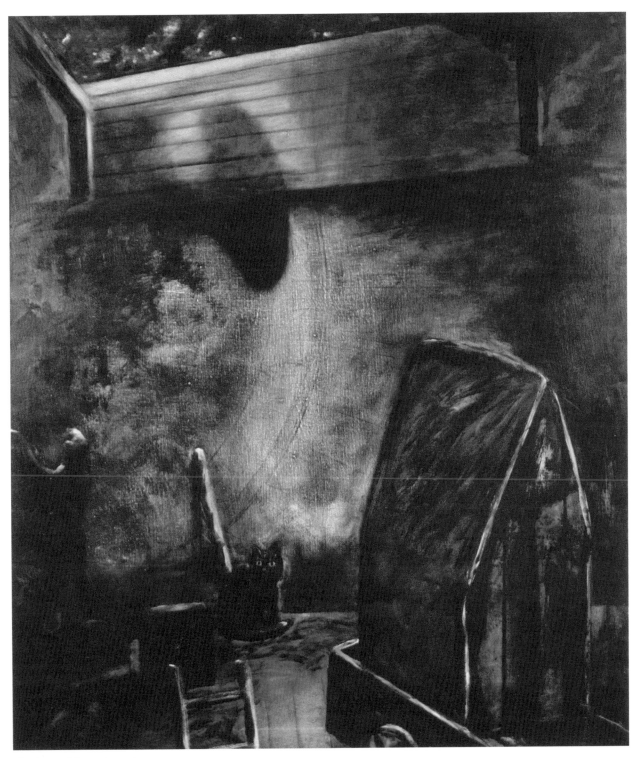

The Tower of Copernicus 1980

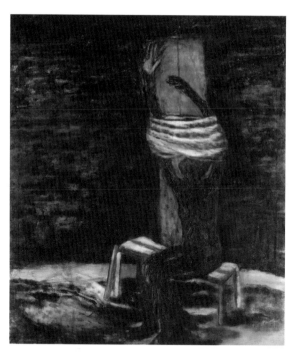

The Black Bride 1986

gabled vehicle has ambiguous resonances: as ark-of-the-covenant, as miniature dwelling (almost a kennel), or half-humorous toy. "I knew instantly when I saw the photograph of the wheeled hut that it embodied certain feelings and provided a 'home' for them."[23]

That word "home" has a special meaning for the displaced. The shelter assembled out of flotsam corresponds to Jackowski's sense of having constructed his own precarious identity. Two years after he had painted his first Tower, he came across an article by John Berger, "A Home is not a House"—"the mortar which holds the improvised home together—even for the child—is memory. Within it, tangible, visible mementoes are arranged—photos, trophies, souvenirs—but the roof and four walls which safeguard the lives within, these are invisible, intangible and biographical."[24]

Over the following decade, Jackowski would extend his wooden realm in different directions, almost as though testing its boundaries. He casts it as an upturned boat, as an ark; or as a hive. He places within it a pregnant woman, as Bride or Queen or Eve-Figure. He lets the seasons loose in the Tower; snow falls, then in *Downfalling* a male figure is suspended among silent flakes, while the woman looks on in stillness. (That slow-motion suspension links to the cinema of Tarkovsky, whose imagery provided a potent exemplar for Jackowski throughout the 1980s.) Partly in response to a poem by Adrienne Rich, *Diving into the Wreck*, the boat-metaphor takes another turn. Long-cherished photos of a Viking ship-burial site suddenly trigger a new imagery of *Rebuilding the City*—of an improvised society, expanding outwards, from the longboat's wooden skeleton, as from a hive.

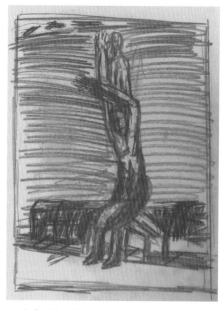

Study for The Black Bride, c. 1984, from a sourcebook.

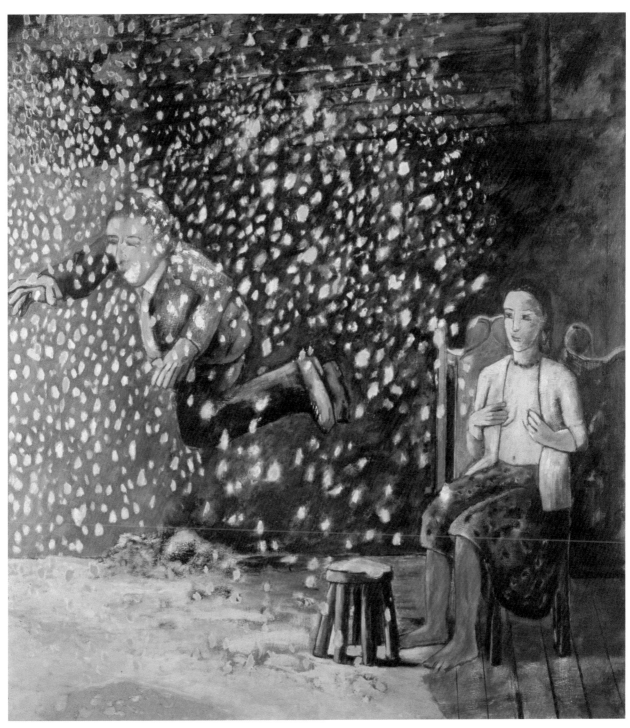

Downfalling 1982

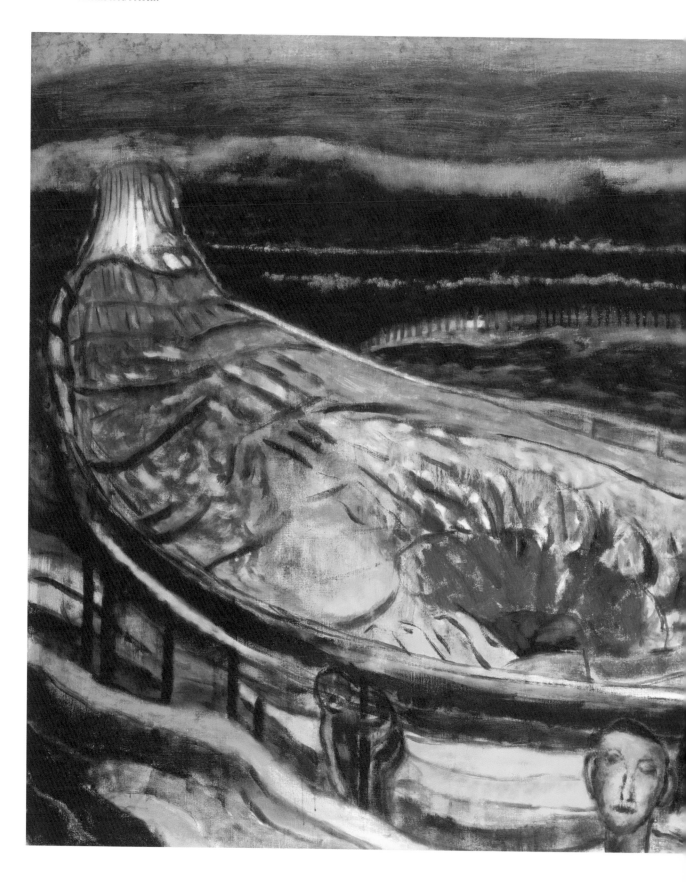

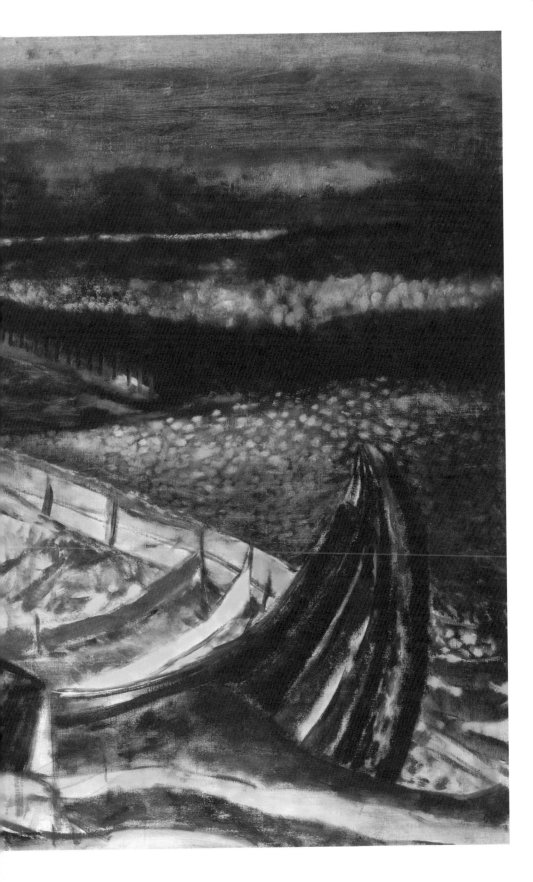

Settlement 1986

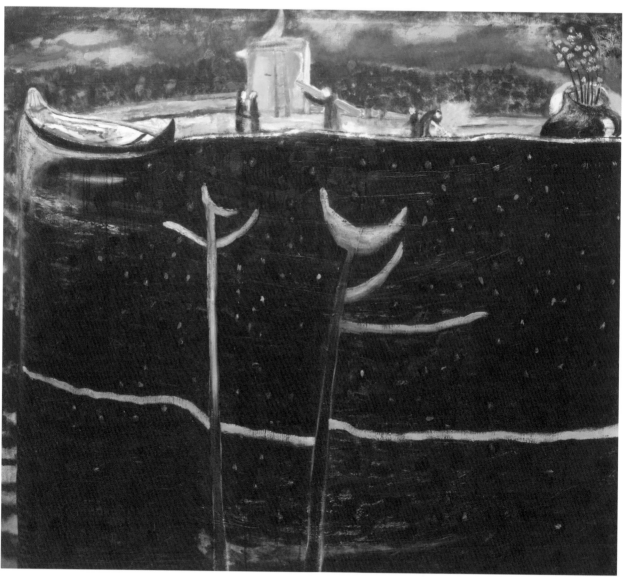

Bower 1987

So the excavated boat becomes a kind of un-burial, "not dying, but coming alive. It felt like a womb opening, or a fruit shedding its seed".[25] (The space is, as Jackowski explained "archaic, mythical, but it is also Brighton, the curve of the bay as you look down on it from the racecourse.")[26] And in *Deeds of Settlement* we are out in the ancestral Baltic forest, facing the vertical screen of close-set trees, from which the horizontal planks of childhood will eventually be constructed.

It would be wrong to think of these paintings flowing easily one from another. Jackowski was never prolific. He sought each new image as a separate expedition, with long fallow periods between, "times when I have to free-float".[27] Occasionally the process seemed one of permutation—of trying-out combinations of previous images, exploring possible resonances. I recall his studio as a kind of cave; a basement in the heart of Brighton, with very little natural light, but a single work on the easel, powerfully lit. Bruno Schultz's phrase, "gloom stitched with phosphorescence" came to mind, and hence perhaps that quality many have commented upon, of Jackowski's forms appearing incandescent, lit from within.

Recognising a 'home' in the spaces he constructed, he felt less certain of the figures who inhabited them. It was, after all, only when Copernicus stood aside that we—spectator and painter—could step in to inhabit the space for our own purposes. Jackowski's figures and heads sometimes seemed more surrogates than protagonists. One solution was to employ a double-scale—a huge head, with much smaller figures in front; or a single large figure on stage among miniature objects. In such compositions, the sense was of the figure experiencing "past and present merged together", of "standing in your own life… with all its little images around it".[28]

In *The Beekeeper's Son*, the most ambitious of these works, a naked boy (almost life-size in the final painting) floats horizontally above a landscape. Head, hands, feet are miniscule; the expanse of stomach and thigh is centred on his erect penis. In the landscape-strip below, we can make out tiny beds; his hovering presence across the night sky seems a materialisation of their dreaming. The title is twisted from a poem of Sylvia Plath, *The Beekeeper's Daughter*: he wanted the same quality of buzzing enigma.

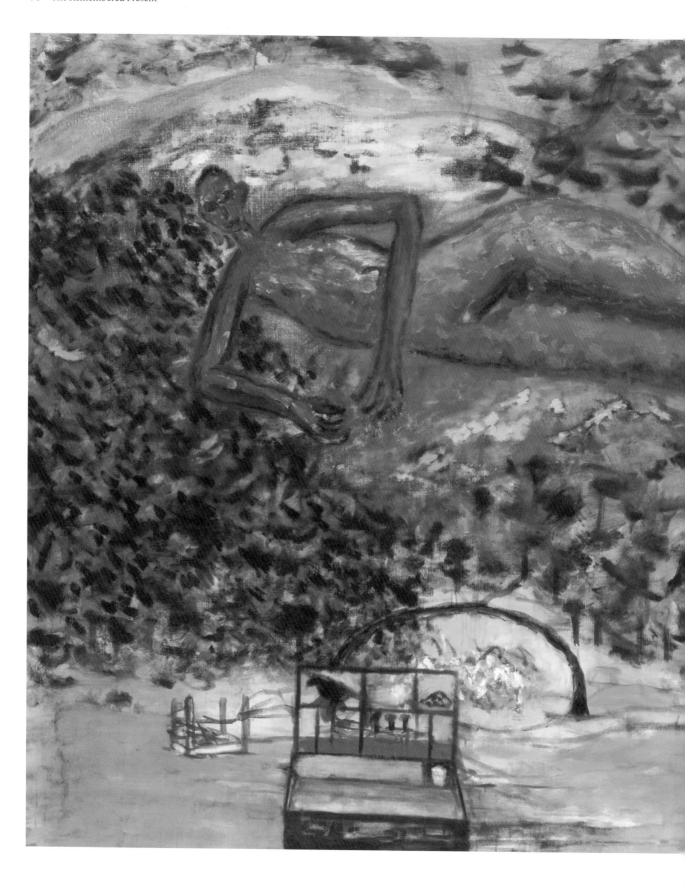

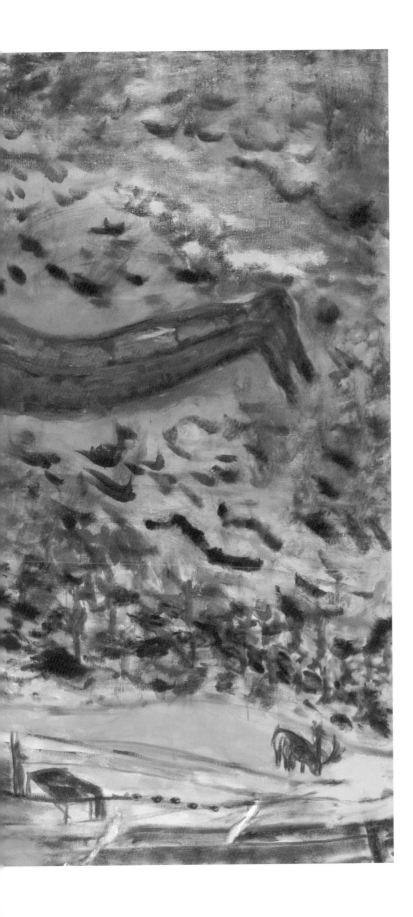

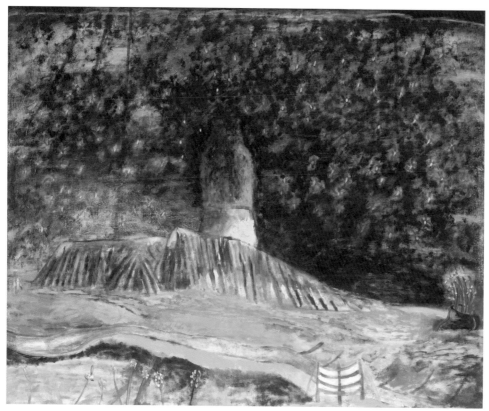

Hive 1989

Reveries of Dispossession 1990–2003

All through the 1980s Jackowski's reputation had steadily grown,
especially among fellow-artists. In 1986 and 1989, he had exhibited
at Marlborough Fine Art (still at that time the leading London dealer
for contemporary painting). When *The Beekeeper's Son* was awarded
the John Moores Painting Prize in 1991, yet another solo show was
hastily mounted. It marked an end, not a beginning; Jackowski
and the Marlborough parted ways shortly after. He found himself
experiencing a kind of revulsion towards *The Beekeeper's Son*: it was
"too fairytale, too romantic, too imbued with nostalgia. I wanted to
make it more present."[29] He embarked on a radical overhaul of all his
most cherished aesthetic convictions.

 The shift was, of course, partly that of an entire art climate.
Jackowski had first come to prominence in the late 1970s, just
when the foundations of Modernism crumbled; when the long
ascendancy of abstract painting was challenged by a renewal
of imagery; when painting itself, so confidently pronounced
dead, rose up again to be re-enthroned as a central medium of
contemporary culture. But in the 1990s—after the art market
collapse that followed the Gulf War—that whole era appeared

in a different light. Painting was seen as having colluded with
Thatcherite consumerism; it became an easy target. Reviewing
the John Moores exhibition, the veteran critic Tim Hilton located
Jackowski's work within "the false naivety and essential timidity
of 80s yuppie painting". In *The Beekeeper's Son* "nothing is defined,
and indeed the merit of the painting is the way it softly changes
focus every time you ask a question of it". It is "a continuum of
evasions".[30] Two years earlier, Jackowski, always self-critical, had
already voiced his impatience with some of his own exemplars. "In
Bachelard there isn't much feeling… it's always to do with stillness.
At the present time, I'm trying to break out of that stillness."[31] By
1992 he was resolved to strip away that beautiful "gloom", that
atmospheric mark from which his earlier imagery had emerged.
One model for a new astringency, especially in drawing, was Philip
Guston, who had so bravely reinvented himself around 1970.

The phrase *"tabula rasa"* often comes to mind in connection
with Jackowski's later work. Even if the table that stands at the centre
of so many of them is in fact loaded (with a garden, a tree, a fox, a
model railway, an entire city aflame) yet these images speak of clearing
away, of a new nakedness. "A table is the sign and symbol of the
human" wrote Gabriel Josipovici, "laboratory for human making and
remaking" (hence the figure who stands at the altar-table in his long
white 'laboratory coat').[32] These images resist any deep space; they are,
explicitly, non-narrative, rudimentary, austere. The spareness of these
images is itself a 'dispossession', with the stage now almost emptied.

Beginning the Game 1991

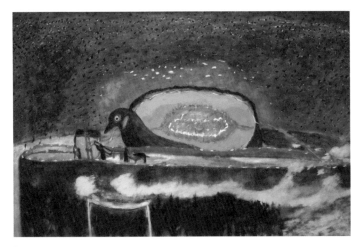

Dove 1990

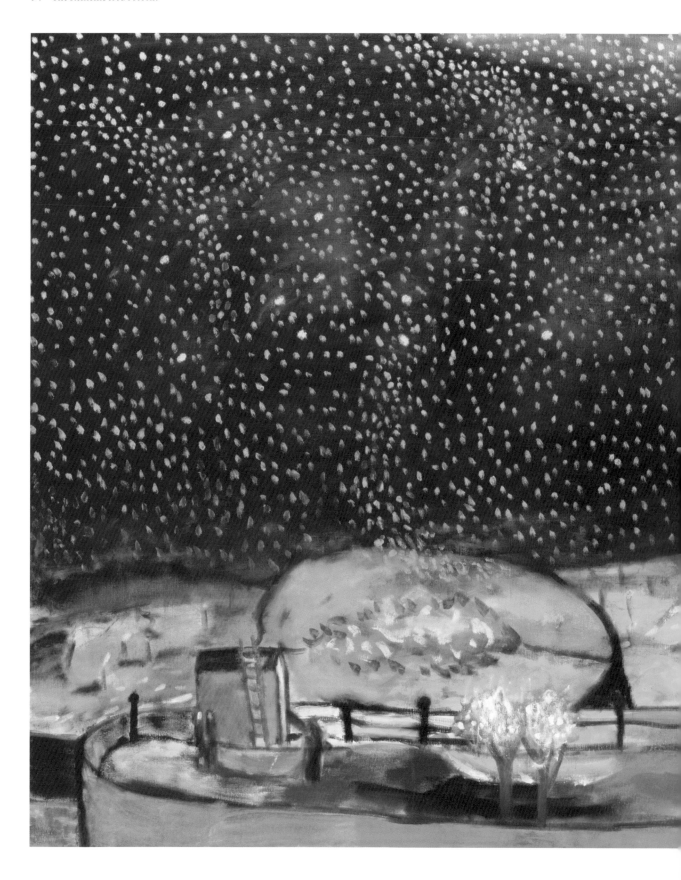

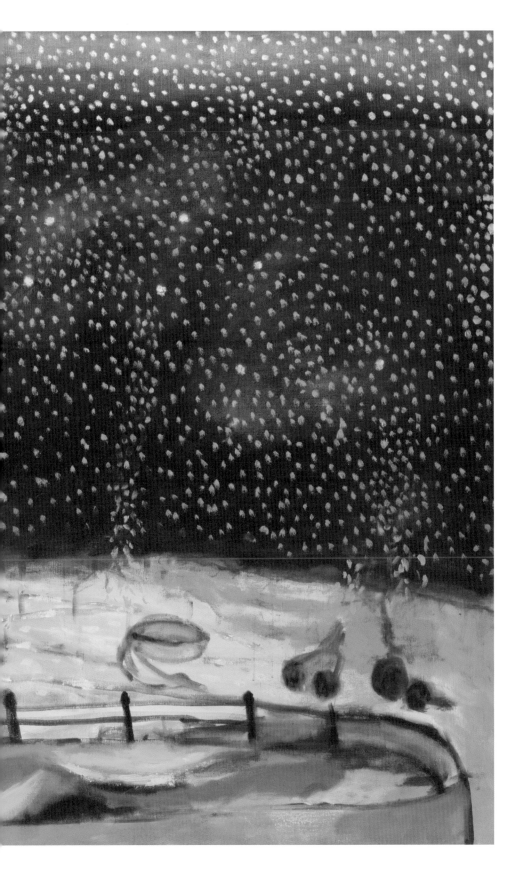

Settling in Drift 1991

History 'In the Next Room'

It had been Jackowski's fate to be dealt, in childhood, a very
specific experience. When he rediscovered in his 30s the imagery
of the wooden barracks, it took on a resonance far larger than any
autobiographical or local predicament. His drawings and paintings
now became imbued with some of the defining events of modern
European history: the concentration camps; the war and its
displacement of populations; the tragic fate of Eastern Europe.
Jackowski's world of wooden slats testifies to a collective experience
of loss, and opens to an imagined 'Poland'. As Paul Overy (writing
of Jackowski in 1986) reminds us: "to be Polish is to have roots in a
nation which has suffered repeated and concerted attempts from its
neighbours to erase it from history".[33] However personal or private
Jackowski's impetus may have been in origin, he ended up, almost
despite himself, creating a kind of contemporary 'history painting'.

 His own personal wounding might be centred in childhood, in
family, in nationality, or in his week-to-week struggle with migraine.
But from the outset, he remained convinced that image-making had
a purpose connected to healing, to reparation, to becoming more
whole. Interviewing him on Radio 3 in 1991, I was astonished how
positively he replied to my 'impossible' question: Did he see painting
as having a function? Yes, he affirmed, the making of art was not a
luxury but a necessity, "we need those kinds of transforming images
like we need to dream at night". More specifically, "the space in the
paintings allows you to dream, so that each image becomes an
invitation for people to enter via the paintings into themselves…
to find areas in themselves which they have lost".[34]

 Jackowski's work of the 1980s spoke for a generation who had
grown up under the shadow of war, but had perhaps only just begun
to understand how deeply it had affected our childhood. In Britain,
some of the most tragic dimensions of the European experience—
invasion, betrayal, civil war—had never really impinged. Gabriel
Josipovici (himself an alien in English culture) spoke of sensing
in Jackowski's imagery, "something that for want of a better word
I would call a European quality that I warm to".[35] So Jackowski's
special role has been as a reminder of, and an intermediary for, a
more 'European' consciousness. His deepest affinities have lain
outside contemporary English culture, and perhaps outside
painting. Although he has admired artists as various as Victor
Willing, Ken Kiff and Anselm Kiefer, he has identified most with
the shamanistic Josef Beuys, the memory-installations of Louise

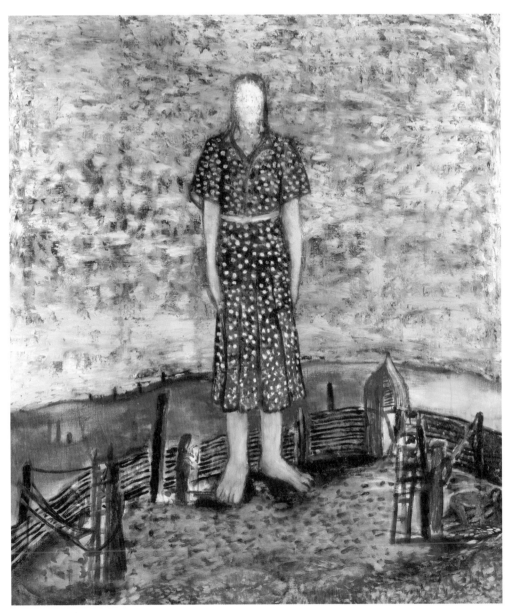

Dreaming Earth 1987

Bourgeois, the dance-performances of Pina Bausch, as well as with filmmakers such as Tarkovsky and Herzog.[36]

A few months ago I asked him whether his childhood had grown more dim. "No", he replied. "Not at all. I constantly revisit it. It stands beside me in the next room, like a second habitation".[37] That sense of intimate contact with his past is part of the thread he shares with the European figures I have listed above. For each of them, out of early memory, out of the 'timeless' dream-space generated by recollection, grows imagery that proves to be charged with an epoch's collective experience.

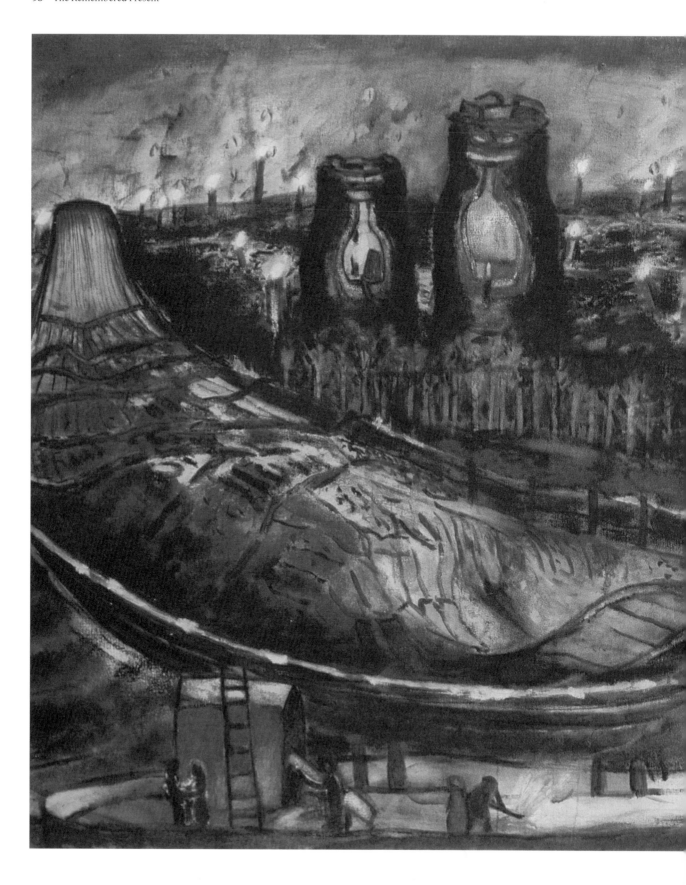

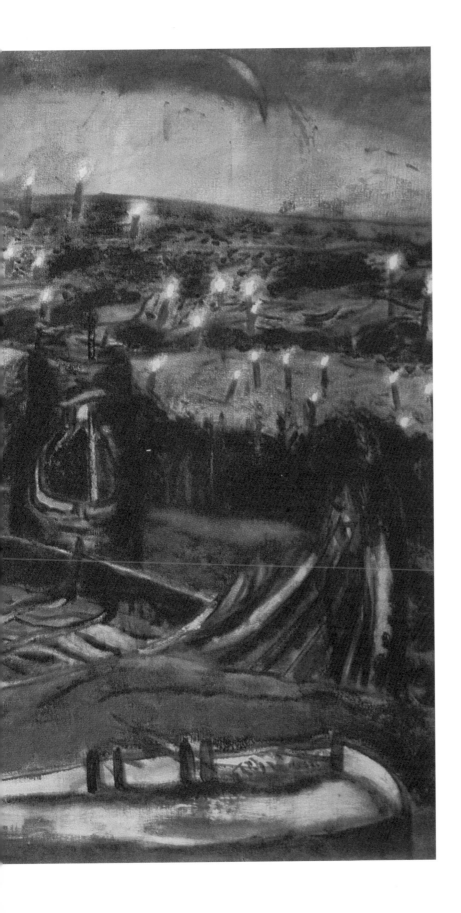

Settlement with Three Towers 1986

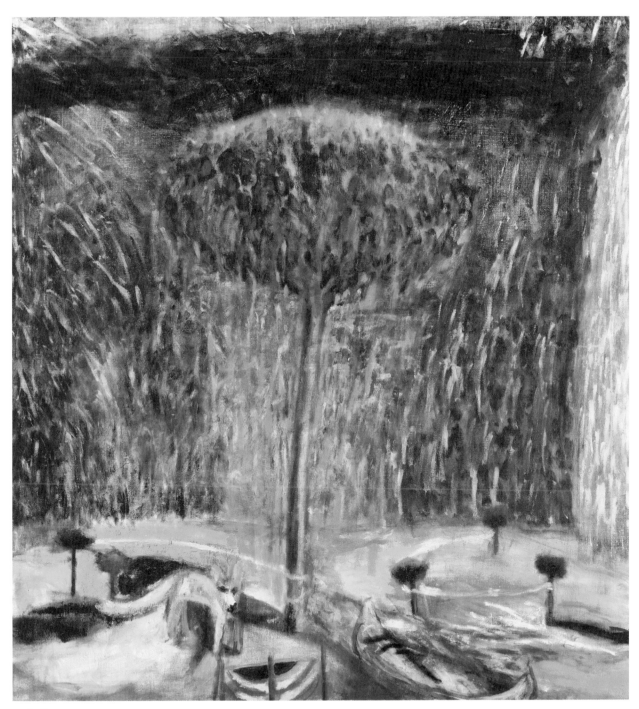

Umbrella Tree 1988

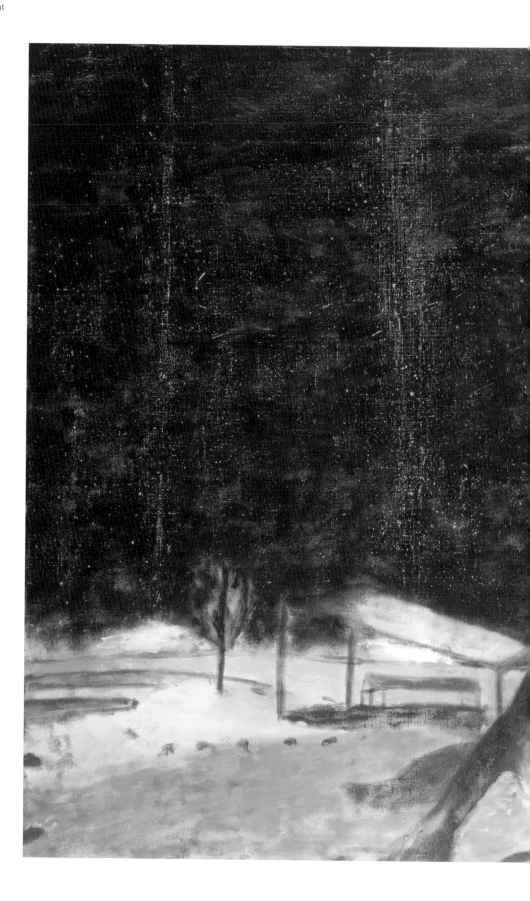

Plans for the City 1989

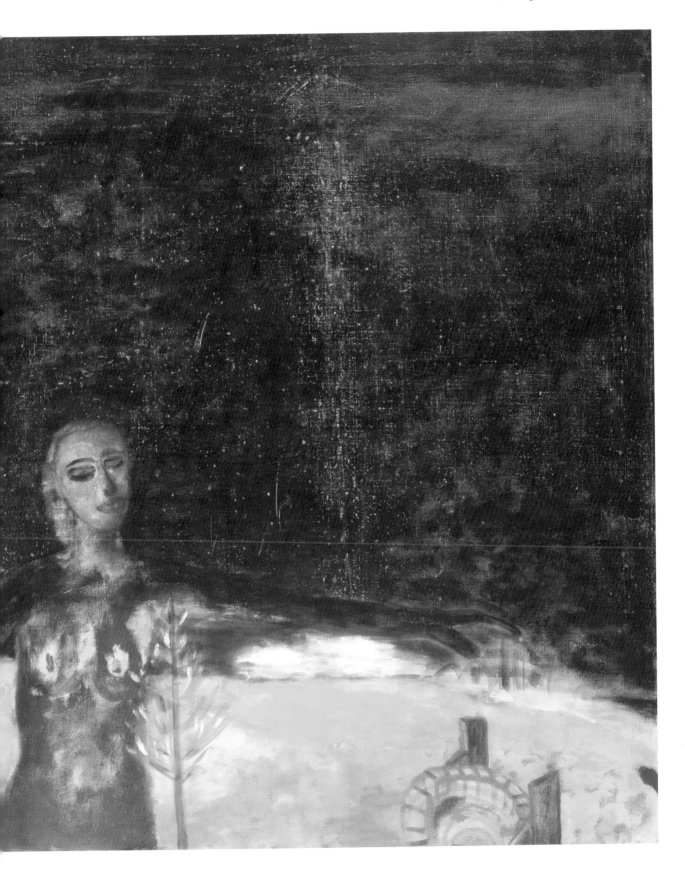

Stored
Andrzej Jackowski

My father was a great carrier of History, Stories and Albums. When he settled long enough in a place he would build and plant a garden where he grew all kinds of vegetables: beans, cabbages, radishes, onions, potatoes. Around the vegetables, there would always be a border of flowers: gladioli, lilies and lupins.

In the late summer, the potatoes were stored for the winter in a straw-lined chamber underground. To get to the chamber one had to enter a small wooden hut and then go down some steep steps, deep into the earth, where the potatoes lay in the straw like eggs in a nest (with a secret dark smell of dreams)—waiting for my mother, one day, to come and gently lift them into the sack.

Photograph of Jackowski and his parents at
Doddington Camp, c. 1949, from a sourcebook.

Reveries of Dispossession
Gabriel Josipovici

Refuge/Refugee

A wooden hut. Five broad horizontal planks make up one wall, against which two narrower planks are leaning. The rough surface of the wood catches the light from the open door, through which one can glimpse a patch of blue sky and other buildings, one of which is topped by a narrow chimney or spire. The floor and the wall in which the door is embedded are also made of wood. The light clings to the edges of the boards and nestles in the roughness of the planks. On the right side of the room, which is otherwise empty, stands a mysterious construction, a sort of Noah's ark on wheels, glowing in the semi-darkness.

There is nothing cold about this room. It is not something we look at so much as something we inhabit. We experience the light and the wooden boards as that which surrounds us, not something merely open to our gaze. Here is a place of refuge.

Because this place of refuge is made of wood it does not feel permanent, yet because it is made of wood it feels protective, human, natural. Each plank has been planed and cut and joined by human hands out of what had once been living trees. The mysterious contraption on wheels, on the other hand, is totally self-contained and faintly threatening, a hooded mover. It has come from another place and will perhaps soon be moving on. Yet the door is wide open, nothing is holding us in here, in this silent and empty hut, whose only inhabitants, other than ourselves, seem to be the light and the shadows, the wheeled ark and the dust on the rough wooden surfaces. And though the silence and emptiness are slightly eerie, they also seem conducive to meditation and the work of memory. No blood will spatter these walls, no screams punctuate this silence. Here we can gather our memories, dream, and wait.

No doubt the hut will one day be dismantled, the whole wooden village too perhaps, and in its place there will, once again, be nothing but fields and trees and mud.

But if the hut is to be dismantled, if the inhabitants will inevitably move on, then this painting, made with as much care, and with its loving workmanship as fully exposed, as the hut, will remain. It will encapsulate memory at the same time as it is witness to an activity. Without the memory there would be no activity, but without the activity memory itself would have disappeared.

The painting then, is no ikon. It is not an object of religious or aesthetic contemplation. Rather, like Chardin's great images of silent concentration, it draws us into the process of living and making as

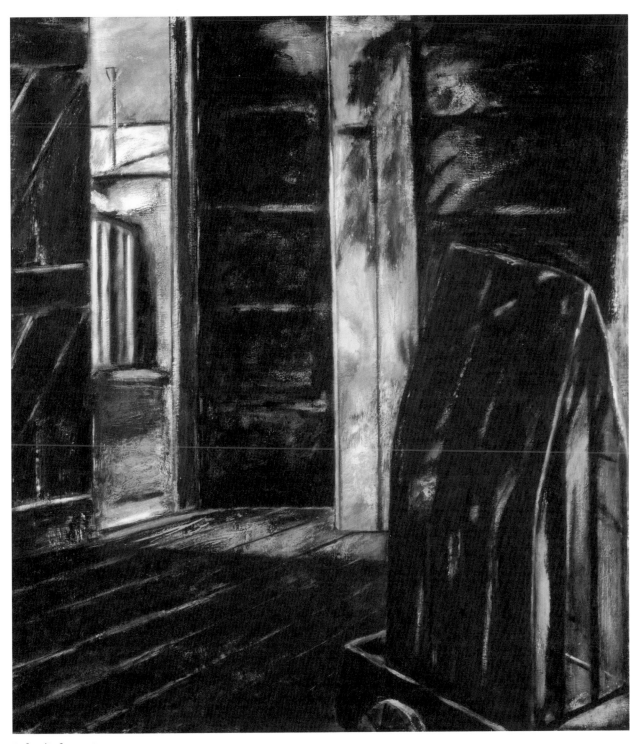

Refuge/Refugee 1982

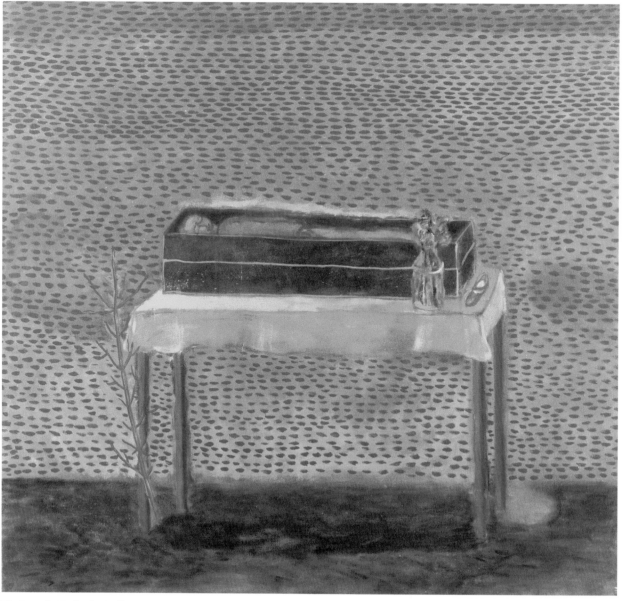

The Boy who Broke the Spell 1996

Study for The Tower of Copernicus 1980

something both wondrous and ordinary, into a space of both refuge and renewal, where we may acquire the strength and confidence to leave when the time comes, as it surely will.

The Tower of Copernicus

There is that mysterious wheeled ark in its corner on the right but here it only seems to be a big toy, for we look down upon it. And it is difficult to see how it got there and how it will ever get out, for the last rungs of a ladder appearing at the bottom of the picture tell us we are on some sort of platform. Clouds whirl down into this space, which seems to be enclosed on all four sides yet open to the heavens above. Mysterious shadows play across wooden walls and, against the wall, next to a tree-stump of a stool, a small black cat sits and stares unblinkingly past us.

Nothing is happening here. The objects appear to have been left standing in this place for a long time. Perhaps once someone climbed the ladder and dumped the little wheeled ark in a corner, sat perhaps for a while on the tree-stump and then climbed back down the ladder. Only the cat sits, unmoving, staring into the darkness, and the sun and moon cast their shadows in turn upon the walls.

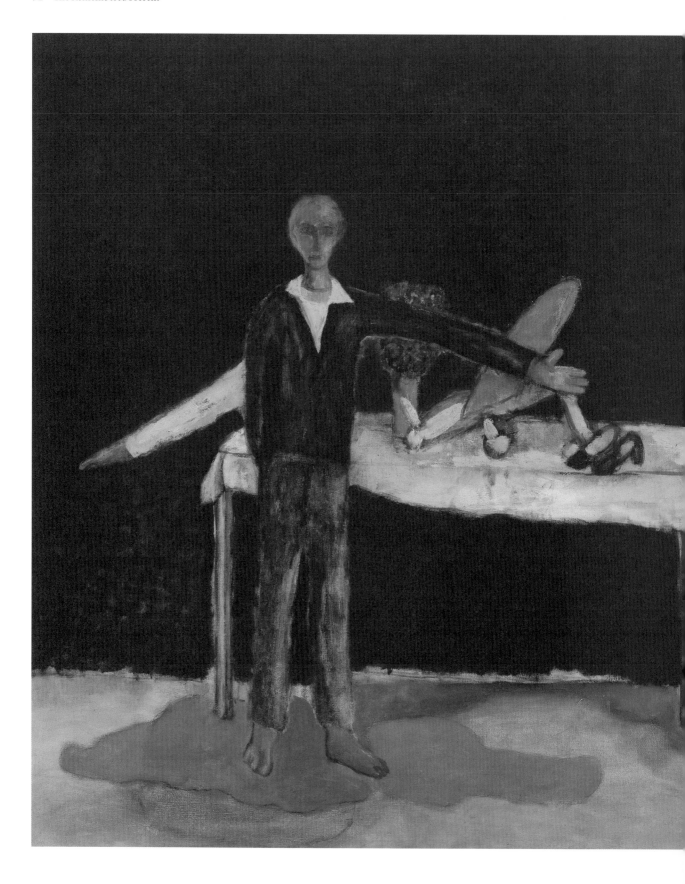

The Covered Table 1994

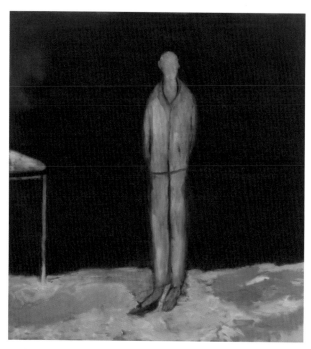

At the Lining of Things 1993

Copernicus perhaps once came here to study the stars and to work out that the earth is not the centre of the universe but only a peripheral planet moving around the sun. But his deserted platform does not convey anything like Pascal's fear of infinite spaces. There is too much sense of the natural and the man-made for that, and the presence of the cat and the little wheeled ark are strangely reassuring. The earth may no longer be the centre of the universe and man no longer thought of as made in God's image, but for whoever comes here this is a kind of centre, a place to gather oneself together and come to some sort of accommodation with the indifferent elements. The whirl of cloud or the tumbling falls of snow of *The Tower of Copernicus – Winter*, the beautifully shaped shadows nestling in the wooden beams of the construction, even the eerie light which catches the walls and floorboards in *The Tower of Copernicus – Autumn*—these are not threatening but show rather the wondrous nature of the world in which we move and have our being. It is a beauty which does not ask to be admired, like the beauty of a sunset or a seascape, but which surrounds us and reveals itself to us as we go about our human work of making ladders, calculating the movement of the stars or painting pictures. It is a beauty which is never still and will never be caught, but which is a part of what we are as we are part of the world of shadows and clouds and stars, of tumbling fluffy snow and whirling summery light, a beauty which is always textured, dense, yet evanescent, the beauty too of layered pigment and raw canvas, testifying to the work of the hand and the brush, themselves a part of our common world.

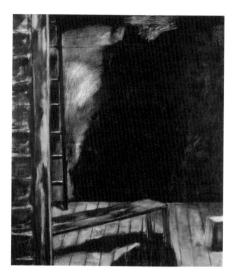

The Tower of Copernicus – Autumn 1982

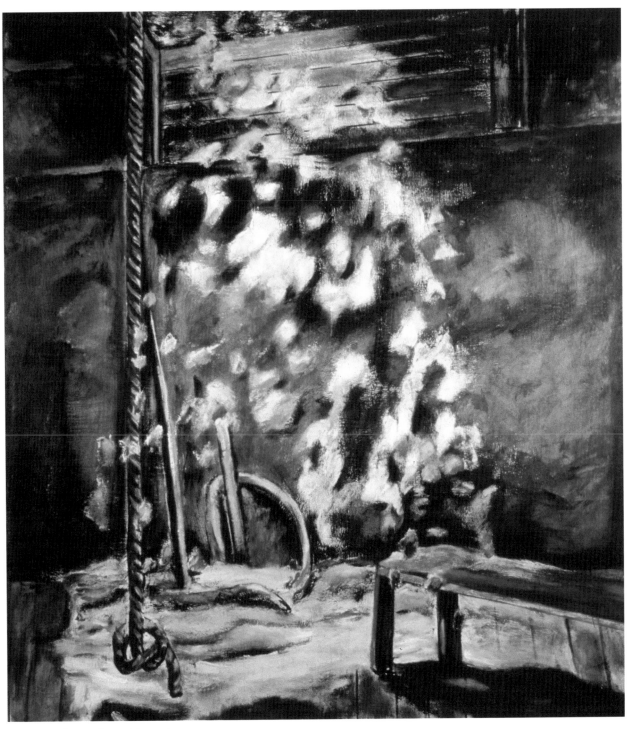

The Tower of Copernicus – Winter 1982

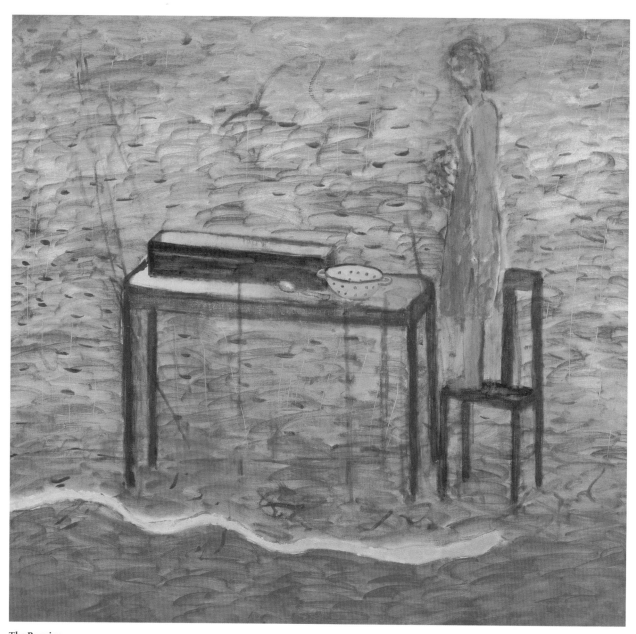

The Burying 1994

The Burying

A table is the sign and symbol of the human. Animals need no tables, and we need them for the two quintessential human activities of communal eating and solitary working. An altar too is a kind of table, on which that other quintessential human activity takes place: the sacrifice to the God. In Judaism and (in a different fashion) in Christianity, of course, sacrifice has been replaced by ritualised communal eating.

In Andrzej Jackowski's table paintings there at first appears to be no community. There is a solitary figure standing beside or in front of a table, or, in one instance, seeming to be part of the horizontal surface of the table itself. But these images are not images of solitude. The walls here are painted with vibrancy and warmth which, even when only a naked bulb hangs from the ceilings, endows the space with that nesting, comforting quality already evident in the hut of *Refuge/Refugee*. And on the table are boxes, sieves, cut flowers in vases, whole cities even, suggesting that the table is less a simple surface than laboratory for human making and remaking.

The strangest of these paintings is *The Burying*, but it is also the key to them all. This is another human ritual: the burying of something precious. Surprisingly in this painter who has brought back to painting the notion of the dappled, what the Greeks called *poikilos* and admired above all other effects, what Hopkins adored and saw as the sign of life itself, and which has been lost to the visual arts since the death of Bonnard, the background to his paintings is bright and harsh, almost painful to look at. And then the river of light snaking across the bottom—is that where the burying is to take place? Or has it already taken place and the object to be buried been safely sealed inside the box on the table? It is an elegant box, carefully constructed. Beside it is a circular white metal sieve or colander, the only round shape in the picture, echoing the wavy line of the river of light below. Like the box, it is made to contain, but also to let out, to sift and allow to be dispersed, an emblem of the whole painting and of the entire series. The girl, so thin, standing on the edge of the chair in her bare feet, has not climbed up out of fear or the desired to escape but seems rather to be lifted up by the flowing presence of the colander. Yet she, like everything else in the picture, is not flying but is firmly rooted by the force of gravity.

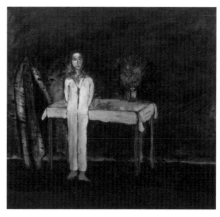

Hide and Seek 1994

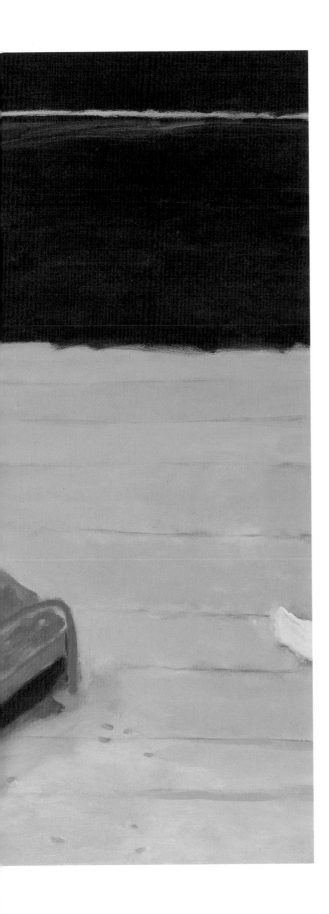

Mother and Son 1999

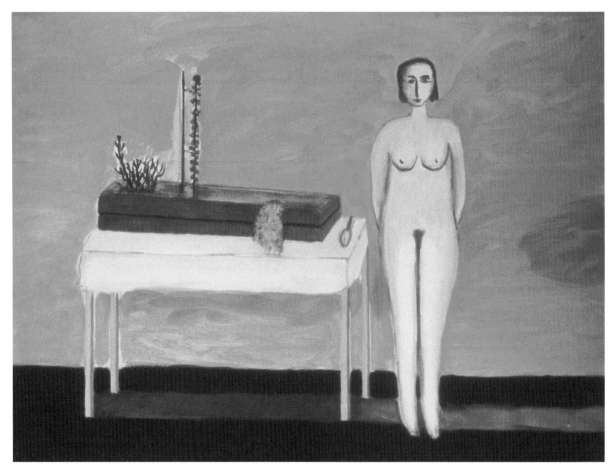

Figure with Small Garden 2001

The title tells us not about her or her feelings but about an activity, perhaps a ritual. It takes no sides, refuses to tell us if this is a repression or expiation. This gives it the authority of ancient story-telling, an authority which it carries effortlessly and which inheres in every part of the canvas, which is, like all these table paintings, completely open to our gaze and yet mysteriously withdrawn from it, returned on itself. It thus, like the Chardins again, makes no claim on the viewer but allows him to enter and leave at will, to wander over the surface or pause over a detail. Something is taking place and, if we wish, we too can be a part of it.

Anxiety and Patience

Temptation, of course, is always present in this work: the temptation of the uprooted to find refuge in myth, to plant the painted tree in painted earth and hope that in this way the foundations can be laid of a home to call one's own; the temptation to renounce the perpetual uncertainty of making, the perpetual re-ordering of elements which are without

prior resonance or significance, in favour of the ready made, the already known, of the dream image, complete, coherent, assertive.

"Because of impatience men were expelled from Paradise", Kafka once wrote, "because of impatience they do not return." The temptations of the artist are always the result of impatience: impatience with the world which will not see what he has made for it: impatience with oneself for failing to find the right objective correlative for the mingled sensations of exhilaration and anxiety which assail one; impatience at the thought that there is not, finally, any refuge from time.

But, set against impatience, is trust. Not confidence, not arrogance,not faith, but trust in the slow and silent work of the hand, in the possibilities of paint and canvas, trust finally in the world of light and shadow, sunshine and snow, of trees and sea and sky. For he who starts with nothing and expects nothing, who accepts weakness and vulnerability, who has learned to live with the fact that even trees do not last for ever—for such a person everything is always possible. As the uprooted tree testifies to the greater power of the storm, as the cut tree brings into the room at Christmas the smell and feel of the forest, so the uprooted exile brings with him far more powerful feelings of what it means to be rooted in our world than those who have always stayed at home can ever know.

Time and memory, anguish and desire tug at us and it is necessary to keep diving back into the wreck, going on through the long night, making our temporary refuges and being prepared, when the time comes, to abandon them without regret. No final revelation is at hand but, with trust and patience, something can be made which will speak truthfully of the joys and sorrows of our condition. And that, surely, is enough.

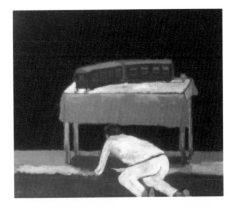

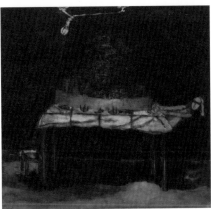

Top **Standing Train** 1997
Bottom **Tearing Apart** 1994

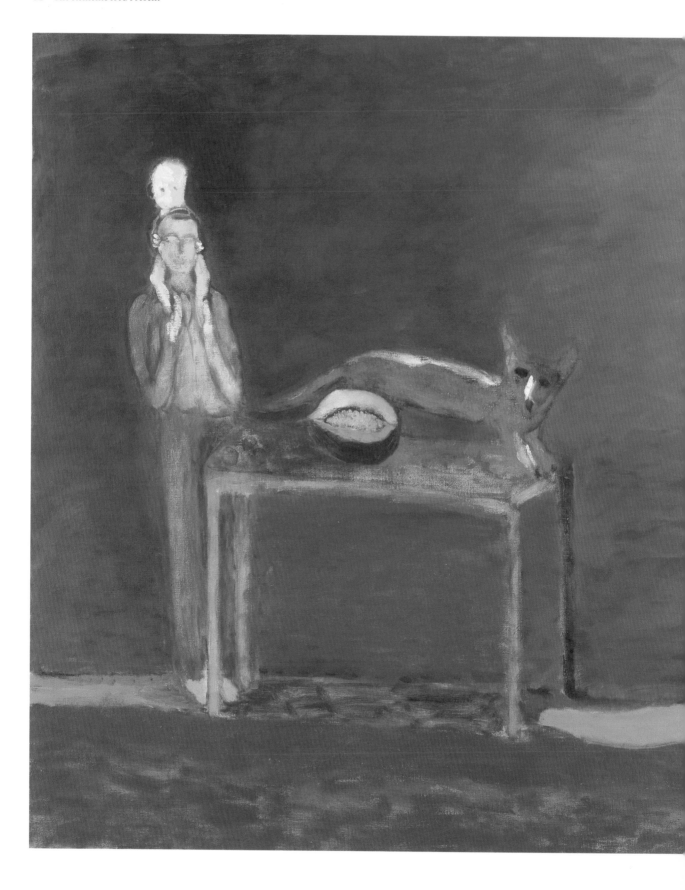

A Child in the Dark 1996

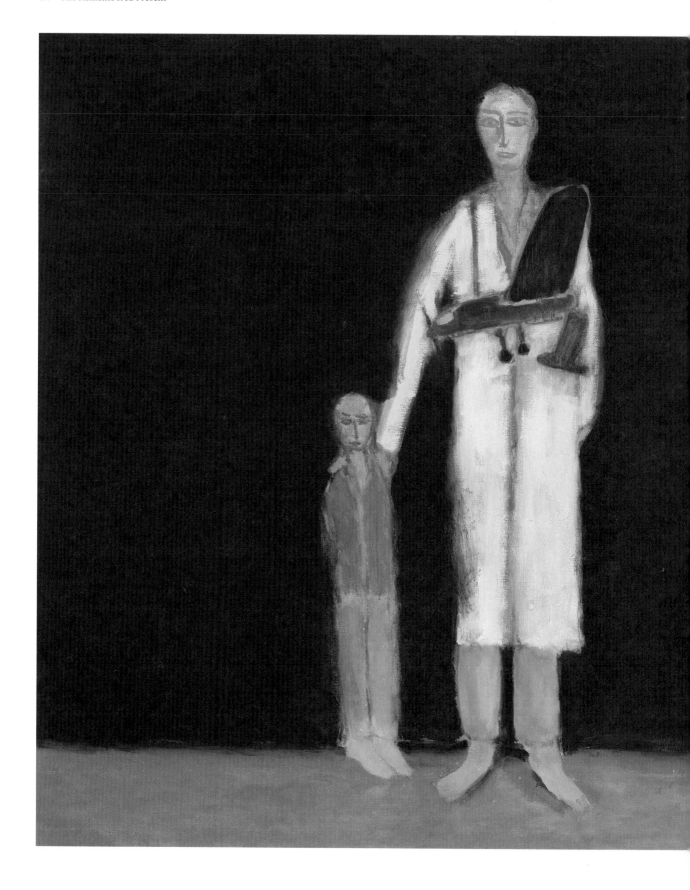

Father and Son II 1999

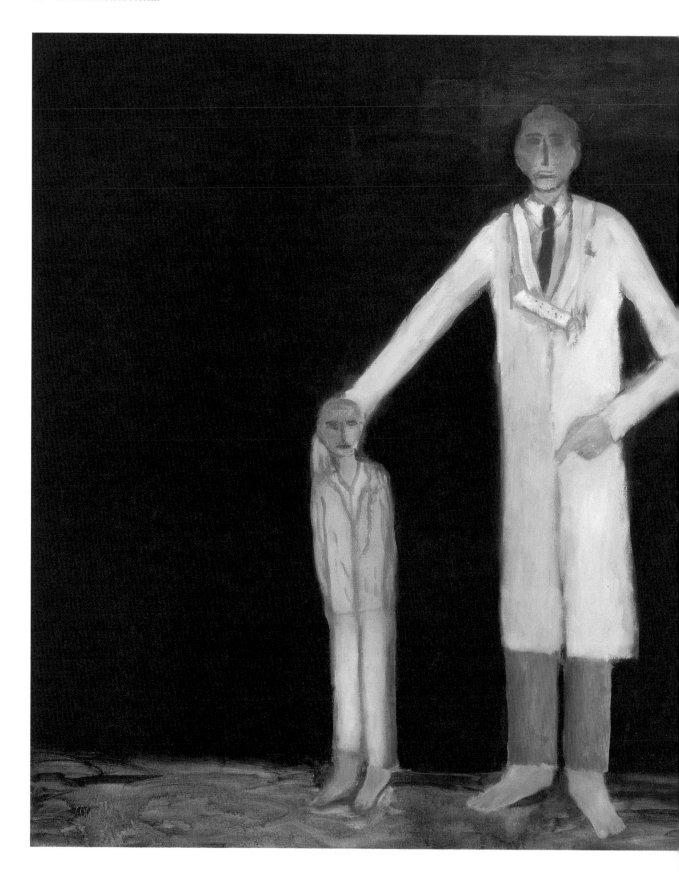

Father and Son III 1999

Study for Two Narrow Beds, from a sourcebook, 1999.

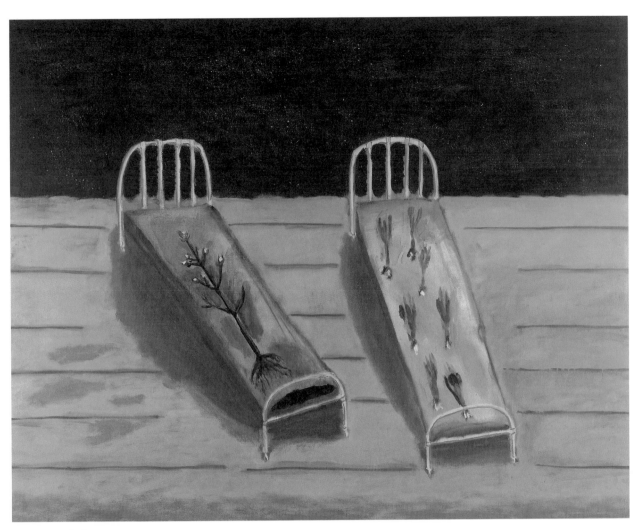

Two Narrow Beds 1999

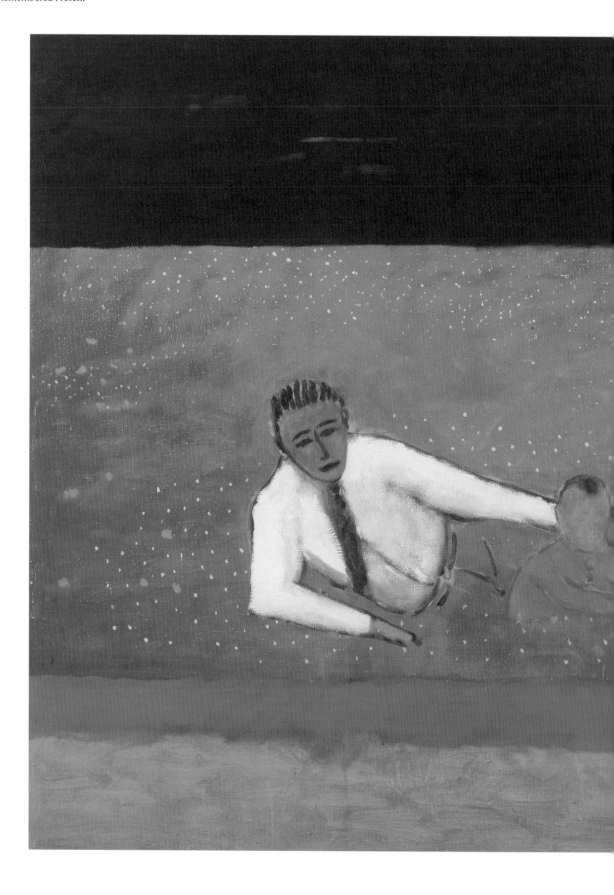

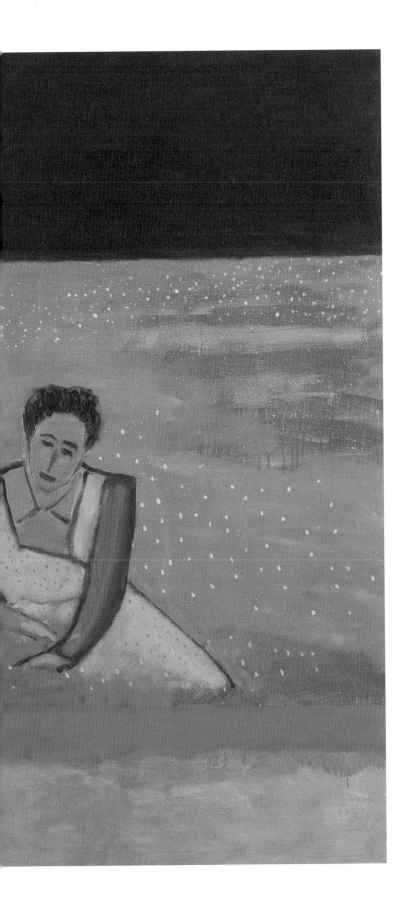

Family 2001

Study for Hearing Voices, from a sourcebook c. 1992.

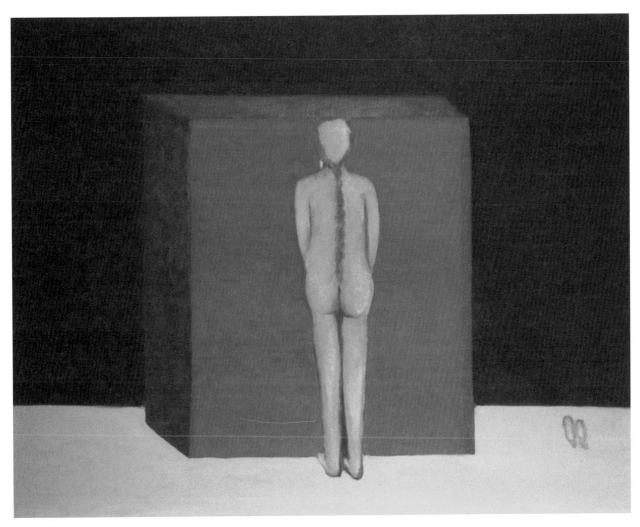

Family Wardrobe 2001

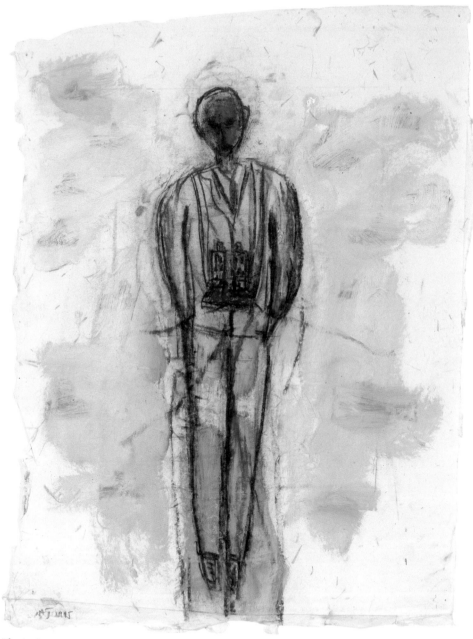

The Assistant 1995

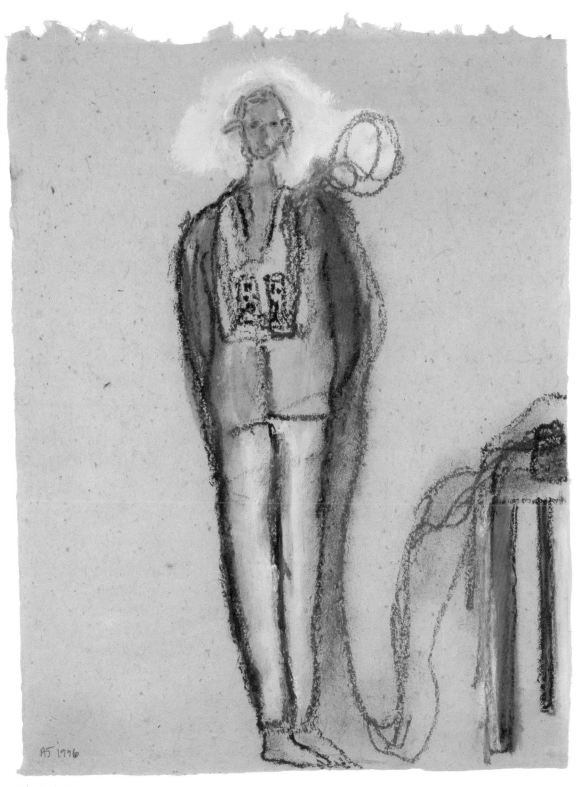

The Assistant II 1996

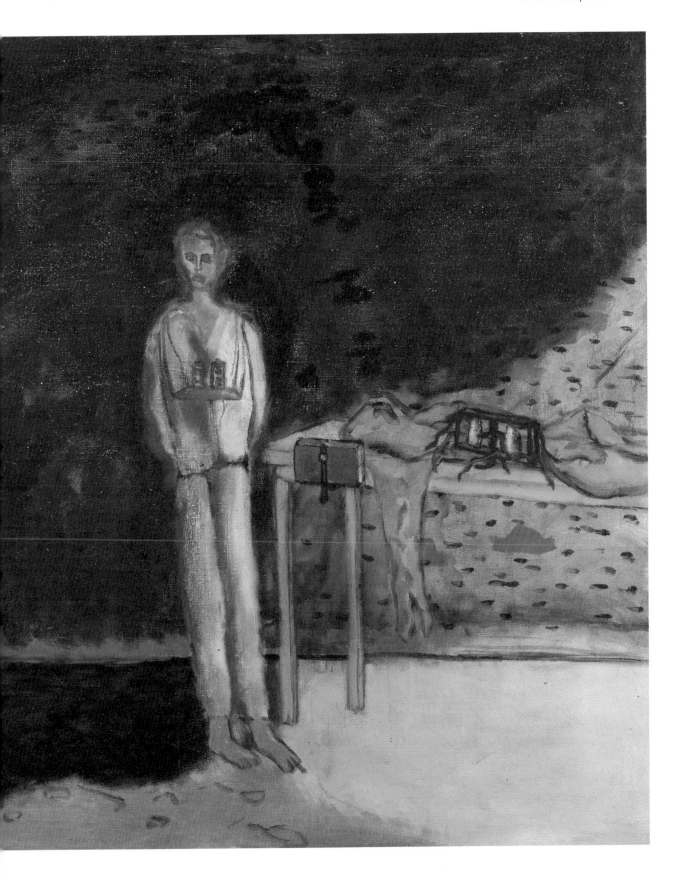

Studies for Hearing Voices, from a sourcebook, c. 1994.

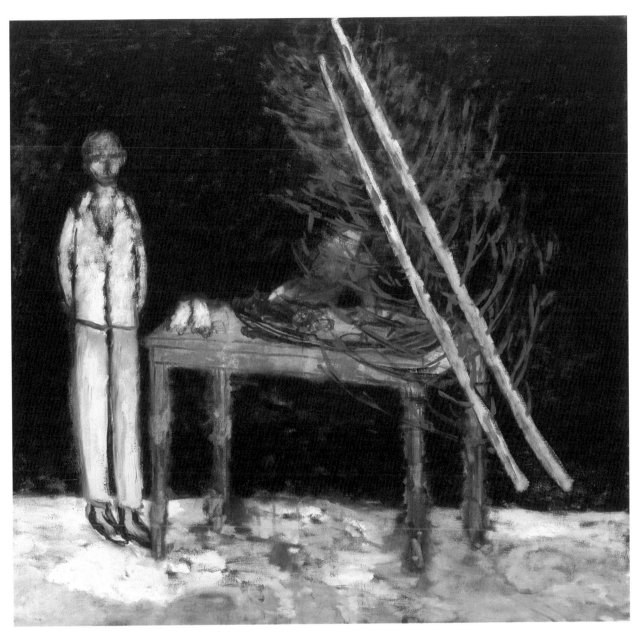

Hearing Voices III 1994

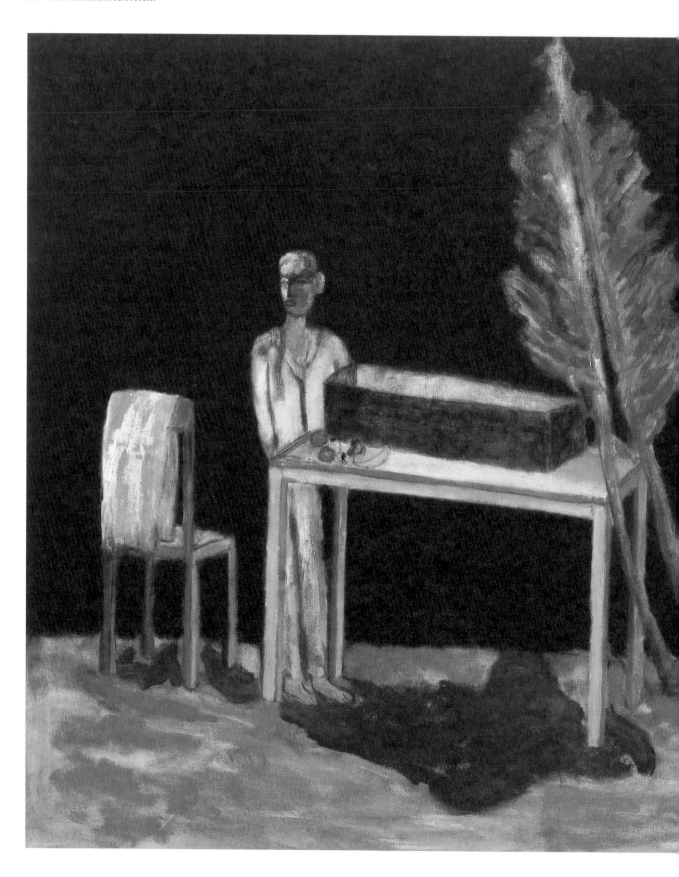

Beneath the Tree 1994

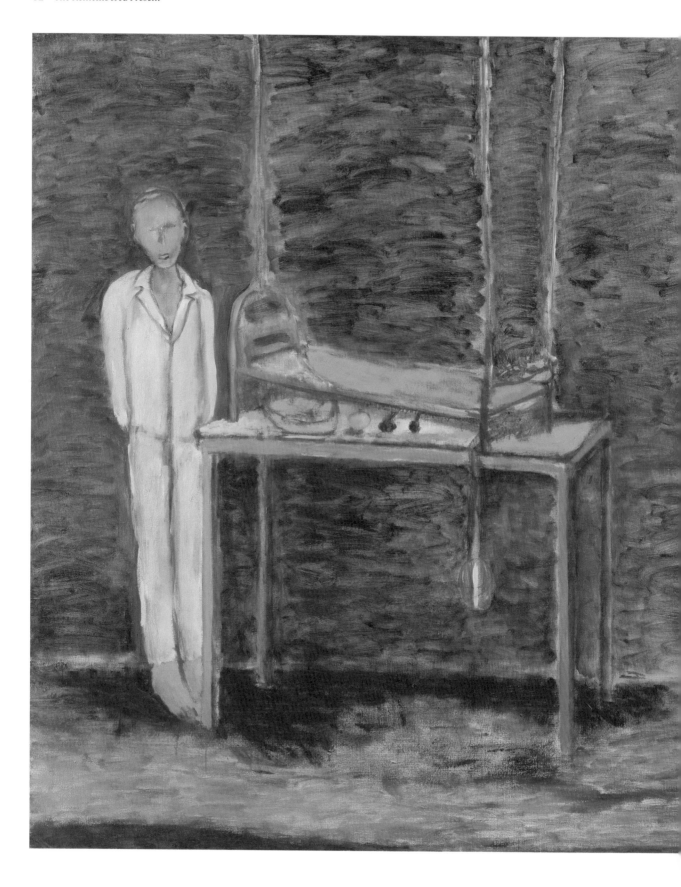

Curing Fruit 1996

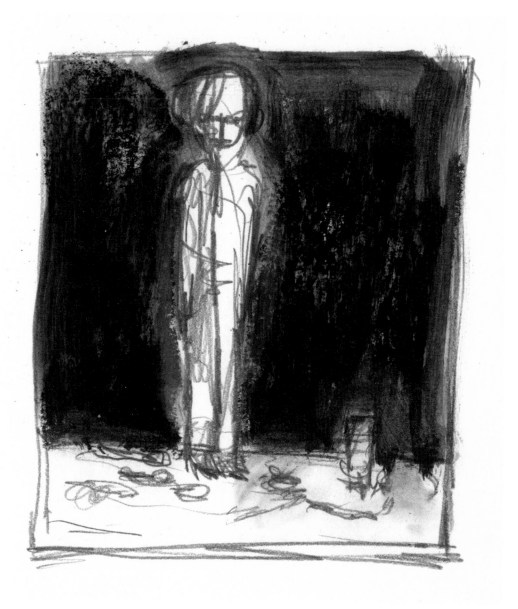

Study for Standing Figure, from a sourcebook, c. 1997.

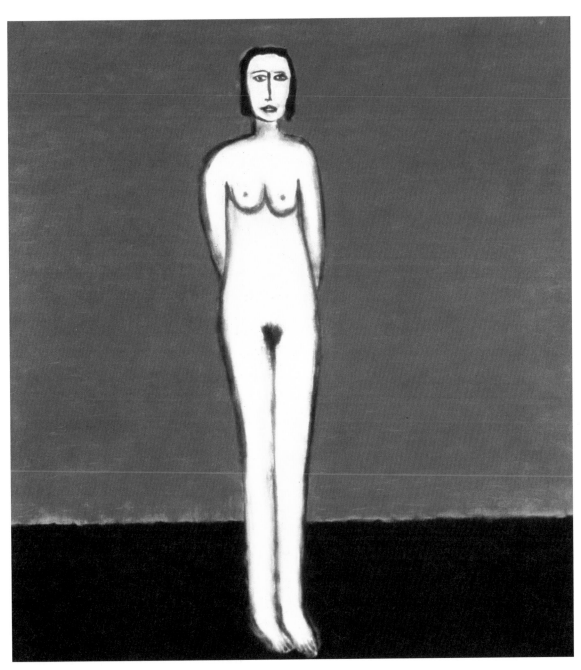

Standing Figure 1997

A Space in the Dark
Andrzej Jackowski

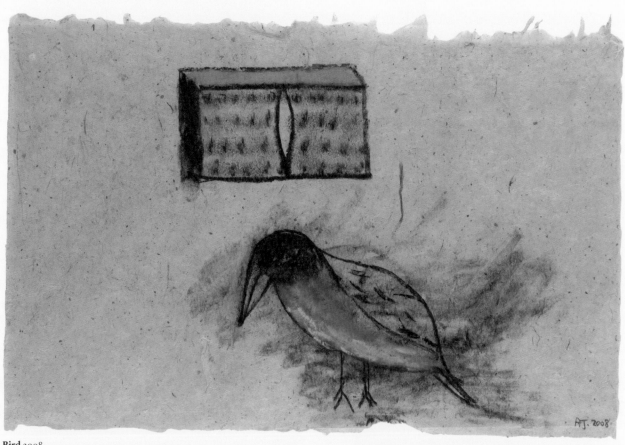

Bird 2008

When I was 11 years old I moved with my parents to London, from
a refugee camp in the north of England—where we had lived in
huts made out of wood and felt covered in tar. We lived with my
half-brother who was a photographer—when I was 14 my parents
separated, about the same time I painted a self-portrait and made a
decision to become a painter.

> Each piece of work
> I have made myself.
>
> I have made darkness,
> I have made pain—
> I have made beehives.
>
> I have made towers
> That look over the sea.
> I have made heads out
> Of reverie and boats
> Lined with dead fruit.
>
> I have made a son out of
> Memory and desire plus
> Wood paint and wax.
> A boy who makes and
> Breaks spells.
>
> I have made tables out of
> Snow trees and sky.
> I have made beds
> With infinite precision.
>
> I have made a dark red bird
> Dream of stories, by
> Adding violet and ochre.

I have made the world small portable and embraced.
I have made a space in the dark quiet corner of my mind.
I have chewed paper and paint, making love cells and secret
chambers—I have used matter and matrix—animals and people
—colour and texture—paint and wax—memory and desire.
I have made myself—a space to live in.

Powerful Now, Like Legends
Michael Tucker

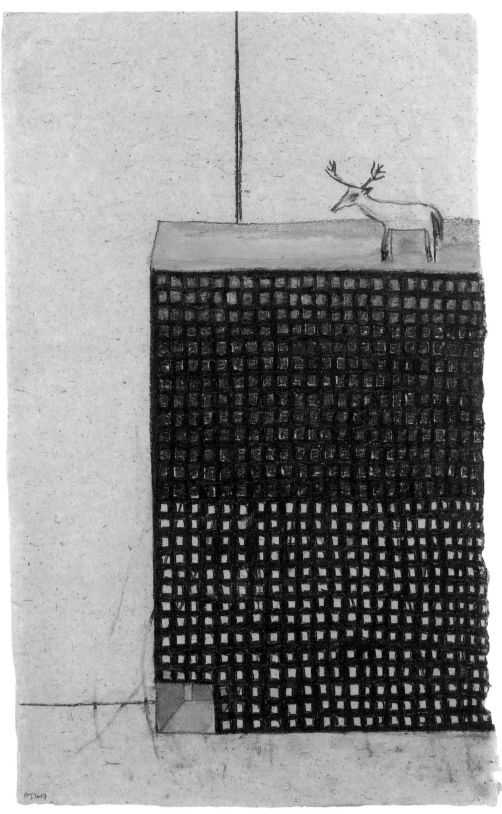

The Early Hours II 2007

I love the dark hours of my being
in which my senses drop into the deep.
I have found in them, as in old letters,
my private life, that is already lived through,
and become wide and powerful now, like legends.
Then I know that there is room in me
for a second huge and timeless life.

Rainer Maria Rilke *A Book for the Hours of Prayer*,
translated by Robert Bly

The late Norbert Lynton began his catalogue essay for the 1986 Marlborough Fine Art, London show *Andrzej Jackowski: Oil Paintings* with the simple but potent declaration: "Andrzej Jackowski is a poet." For Lynton, Jackowski was a maker of "visual poems" the motifs of which had become "milestones without inscriptions".[1] 20 years on, after a number of related observations from such further authoritative voices as Peter Abbs, Gabriel Josipovici and Timothy Hyman, John McEwen concluded his catalogue essay for Jackowski's 2005 Purdy Hicks Gallery, London show by noting that "[...] Jackowski has consistently found inspiration in poetry. The word 'poetic' is not favoured much in art criticism these days; but is there a better way to describe this sense [in the work] of the inner life, this concentrate of feeling tinged with melancholy and described with infinite precision [...]?"[2]

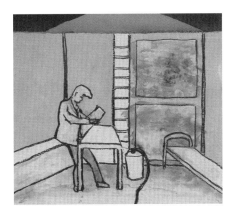

Those art critics who might wish today to turn away from any idea of the poetic, and who would perhaps prefer to speak of the overriding importance of something called "theory", could do worse than recall the wise words of Édouard Vuillard: "Who speaks of art speaks of poetry. There is no art without a poetic aim. There is a species of emotion particular to painting. There is an effect that results from a certain arrangement of colours, of lights, of shadows. It is this that one calls the music of painting."[3] One recalls the extent to which Renaissance theorists built their ideas of pictorial structure and meaning upon Horace's famous aphorism *ut pictura poesis*—"as is painting, so is poetry" (*Ars Poetica*, 36). However, what might constitute, or embody, the idea of painting as silent poetry today is very different from what it was in the classically ordered and oriented world of the Renaissance.

For Braque—one of the most poetic and intelligent of all twentieth century artists—the High Renaissance in particular was in

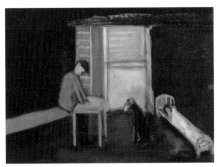

Top **The Voyage** 2003
Bottom **The Lesson** 2005

large part a conceptual error. Its consummate mastery of linear and aerial perspective had served only to distance us from the world: hence for Braque, the chief poetic task of painting was to make space once again palpable, tactile; to bring pictorial events up to the surface of the picture plane, the better to encourage a sort of multivalent "participation mystique" in the onlooker.

If the invitation to such participation runs all the way through the œuvre of Andrzej Jackowski, it is especially evident in the most recent work. In paintings such as *A Space in the Dark, Cells, Dwelling* and *Vigilant Dreamer* human figures and landscapes, buildings, animals and birds are presented to us in a combination of concrete, primitivistic frontality, dream-blown shifts of scale and perspective, and an exquisitely adjusted interplay of pure and mixed colour with a subtle variety of surface and texture. As John McEwen notes in his essay for Jackowski's 2005 show at the Purdy Hicks Gallery, the imagery in such work often inhabits "what would otherwise be an 'abstract', quite geometric, painting".[4]

In these recent works, then, Jackowski is able to offer fresh perspective on the classic Surrealist question of how best to "picture" and transmit the transformative power that might lie within dream imagery.[5] He also brings a new inflection to Jarry's astute insight that telling simplicity is complexity stretched taut, as well as to Brancusi's congruent perception that, while simplicity should not be a conscious aim in art, we arrive at simplicity in spite of ourselves, in approaching the real sense of things: "Simplicity is at bottom complexity and one must be nourished on its essence to understand its significance."[6]

Striking in its ostensible simplicity, thoughtfully—rigorously—achieved, the painterly exactitude of Jackowski's recent work bodies forth the kind of dream-charged poetic openness of effect (in both overall visual field and symbolic figuration) that speaks equally of a deep penetration and a transmutation of the historical or socio-political crust of life. As such, it exemplifies a crucial, long-evolving shift in both the poetics of painting and the democratisation of art.

In his aforementioned essay from 1986, Norbert Lynton offered a perceptive *précis* of the way in which the poetic imperatives of that grand, post-Renaissance tradition known as "history painting" had been both transformed and recharged, following the highly personal visionary insights of artists such as Blake and Goya:

History painting employed well-known literary or historical themes, illustrated but also commented upon and rethought by

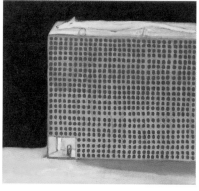

A Space in the Dark 2007

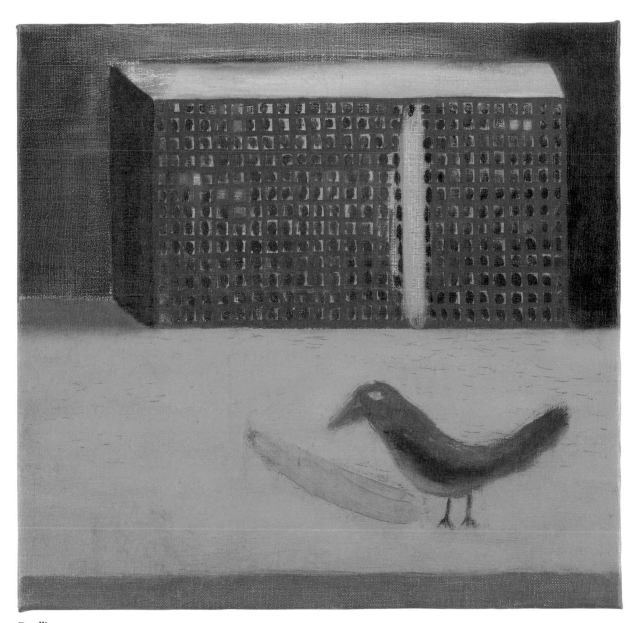

Dwelling 2007

the artist. Now he turns not to Virgil or Plutarch or the Bible but to himself. The material is within, and we believe that the deeper he digs the more likely he is to mine veins that run through us all. His purpose, however, is to take an ever surer hold on the elusive ore that is both motif and motivation, and to bring into one operation the functions of craft and technique.[7]

If the word "poetic" is not much favoured in some circles today, what Lynton calls "the functions of craft and technique" have often been similarly neglected, even actively disparaged. But not by

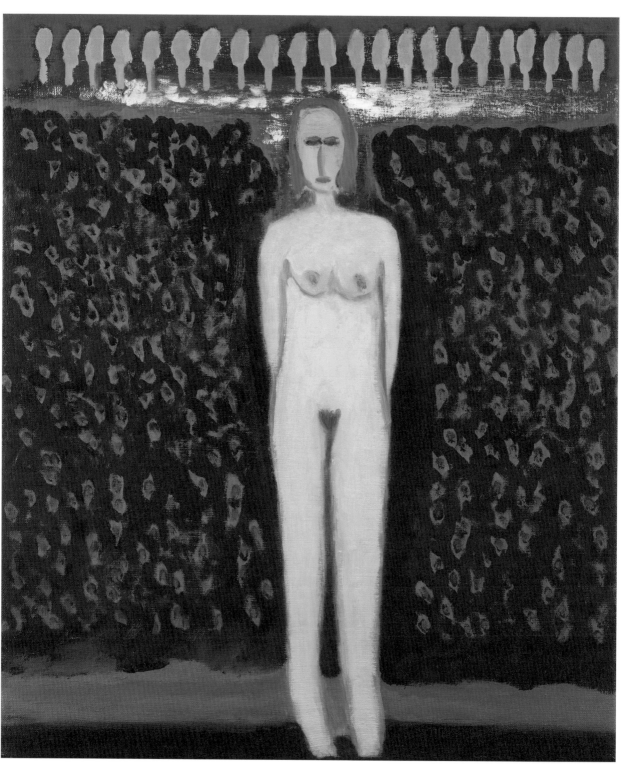

Woman with Bees 2009

Jackowski: far from it. In John McEwen's 2005 essay, the painter is quoted as follows: "I love the evocative power of texture [...] It's not just imagery which makes things work. It is the meeting of shape and colour and the rhythm and pattern they make."[8] The poem which Jackowski contributed to the catalogue for his show *A Space in the Dark*, held at the Purdy Hicks Gallery in 2007, emphasised the idea of making.

A key question arises here: what makes a convincing painterly or poetic space? What makes us want to return, again and again, to an especially compelling image in paint, or an equally arresting line in poetry? Developing the analogy between poetry and painting, one might say that, in the best lyric poetry/painting the 'materiality' of language/paint fuses with the yeast of simile and metaphor/texture, relations of line and colour, to produce something quite remarkable. For the more 'substantial' or 'material' a lyric poem/painting would seem to be—that is, the more precise, potent and unalterable its language/visuality—the more it is able to precipitate the flight of consciousness beyond itself, whether that consciousness be linguistic or visual in nature, belonging to the maker of the work or the engaged onlooker.

The Swedish lyric poet Gunnar Ekelöf (1907–1968) had a strong interest in painting, writing incisive essays, for instance, on Degas and Dürer, the pre-historic art of the Lascaux caves, Edvard Munch and the Swedish 'outsider' artist Carl Fredrik Hill. What Ekelöf observed about the power of a good poem is equally applicable to painting. For Ekelöf, such power was generated less by a poem's overt content than by the state of tension between the words which offer up that content. As Ekelöf put it in an essay from the early 1950s, poetic power comes from "the poet's ability to place word and meaning in such refractive and subtle relationship that the emptiness quivers, lives, registers, transmits, and is a magnetic web of sorts, composed of invisible thread and power lines which attract or repel each other."[9]

We have already registered a comparable play of elements of abstraction and figuration in the recent work of Jackowski: Ekelöf's image of a magnetic web can encourage us to think of the variously distributed and synthesised poetic energy in paintings such as *A Space in the Dark*, *On the Edge* and *Woman with Bees*. Exemplary here is *The Remembered Present*, with its subtly pitched homage to Carlo Carrà: the image within the image here is a paraphrase of the Italian's *The Pine Tree by the Sea*, a deeply affecting work which has also inspired a poem by Jackowski.

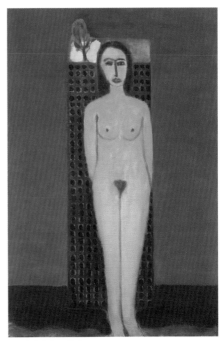

Woman with Tree 2009

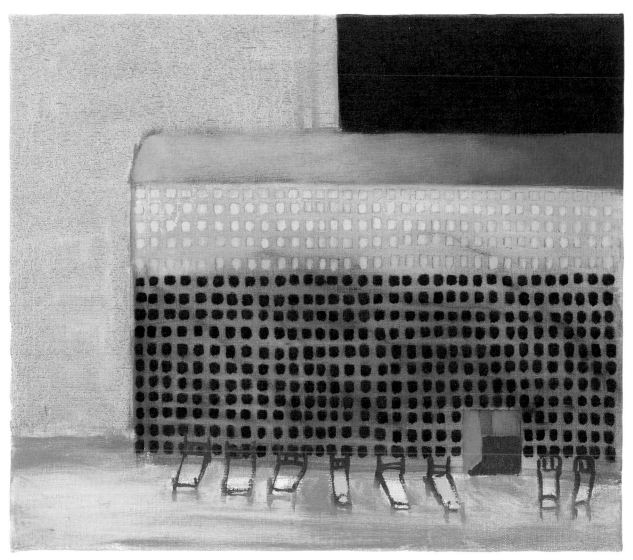

Sanatorium II 2007

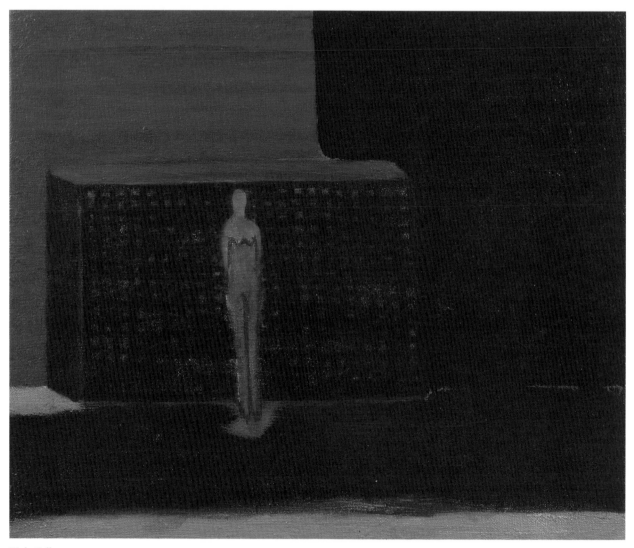

Night Cells 2005

The philosopher Francis Bacon spoke disparagingly of poetry as but "a dream of learning". However, for the French writer Gaston Bachelard—long an elective affinity of Jackowski's—there could be no better way to develop and deepen one's sense of both self and world than by attending to the call of the sort of charged poetic matters of which Ekelöf speaks—and which so distinguish the work of Jackowski. These are matters that can serve to recall us into cognisance of the larger being of both ourselves and the world: into what one might call the replenishing mystery of a creatively open sense of the remembered (re-membered) present.

One thinks of such diversely mytho-poetic images of Jackowski's as *Breath-Space*, 1987, *Night Cells*, 2005, and the *Vigilant Dreamer* works from 2009. The reverie—the open-eyed dreaming—induced by a compelling poetic image reminds us, said Bachelard, that in this life, we have the capacity to breathe freely, deeply and well. In breathing thus, we might come to awaken from the nightmare that history so often can be, as Joyce put it.[10] A considerable part of the importance of Andrzej Jackowski's work lies in the extent to which that work is able to engage creatively with both personal memory and the wider historical domain, as it comes to transmute the seemingly irresistible pressures of history and politics through the evolution of a distinctive mytho-poetic language: a language as intimate and personal in its painterly nature as it is expansive and transpersonal in potential import.

The various interviews which Jackowski has given over the years reveal an empathy with an historically wide range of essentially poetic work: from Giotto and early painting from Siena to Balthus, Carlo Carrà and 'Douanier' Rousseau; from Edvard Munch and Joseph Beuys to Louise Bourgeois and Anselm Kiefer; from RB Kitaj and Victor Willing to Roger Hilton and Ken Kiff. Practitioners of Art Brut, the poets Peter Redgrove, Rainer Maria Rilke, Seamus Heaney and Adrienne Rich, the writer Bruno Schulz, dancer Pina Bausch and filmmaker Andrei Tarkovsky have been of scarcely any less account to Jackowski. He has remarked of the last-named that "Probably there's no contemporary artist I feel so close to; he's of the same family, a soul-brother."[11]

Part of the reason for such empathy lies in what Jackowski calls a peculiarly Slavic ability in the Russian filmmaker to be at once concrete and spiritual in the making of the work. Such a healing synthesis has long been a chief distinguishing characteristic of Jackowski's own art. Anyone who has relished films by Tarkovsky such

Breath-Space 1987

Horse I 2004

as *Ivan's Childhood*, 1962, *Mirror*, 1974, and *Stalker*, 1979, will sense what a range of correspondences may be posited between such multivalent work of the Russian master and Jackowski. These are correspondences rooted in fundamental questions of our understanding of, and approach to, the factor of time in human experience; to memory and imagination, love and loss, yearning and fulfilment.

Time could not exist, said Aristotle, without a soul to count it. But as Bergson knew, for a soul to experience the duration of time can never be a simple matter of measurement or mathematics. For Tarkovsky, the counting of time meant very little, in contrast to the life-long quest of this director somehow to "let time live in the image".[12] This is exactly what the paintings of Andrzej Jackowski achieve, and on several levels at once. The time that Tarkovsky (1932–1986) talked about had a great deal to do with concrete questions of history and politics, with the trauma of life as lived under Soviet Communism. However, Tarkovsky always addressed such pressing matters within a transfiguring poetic context: a context built out of the deepest engagement with questions of personal memory, evolving spiritual identity and the redemptive, even Paradisal, potential of art.

Exactly the same may be said of Jackowski. Over the years, certain details of the artist's biography have become familiar: his Polish roots, his birth in a Polish hospital in North Wales, and the 11 years of his early upbringing with his father and mother in a camp for refugees near Crewe. Given this, it is understandable that a good many commentators have seen this artist's work in terms of the intertwined themes of dispossession and melancholy. And these are themes which can be seen as having both national and historical import. As Timothy Hyman has said, "However personal or private Jackowski's impetus may have been in origin, he ended up, almost despite himself, creating a kind of contemporary 'history painting'."[13]

From this perspective, it is possible to see the painter's most recent low-lit settings of solitary human figures against seemingly anonymous blocks of buildings in terms of an emblematic lament for life as suffered in the totalitarian world: as a sort of unillustrative yet vivid visual counterpart to that combination of cryptic social criticism and compassionate humanism which is to be found, for instance, in the poetry of the Pole Zbigniew Herbert or the Czech Jaroslav Seifert.[14]

However, one must recall here Norbert Lynton's crucial insight into the changing nature of the poetic imperative in history painting,

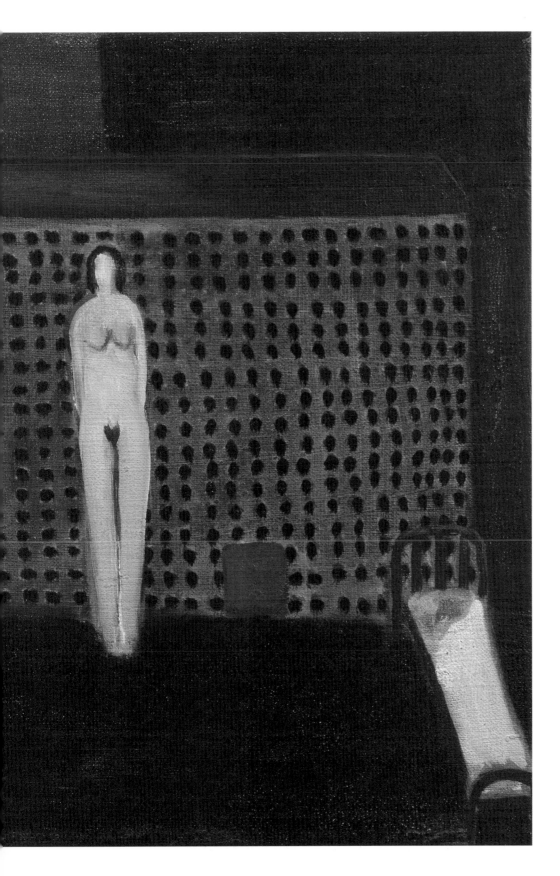

Love Cells 2005

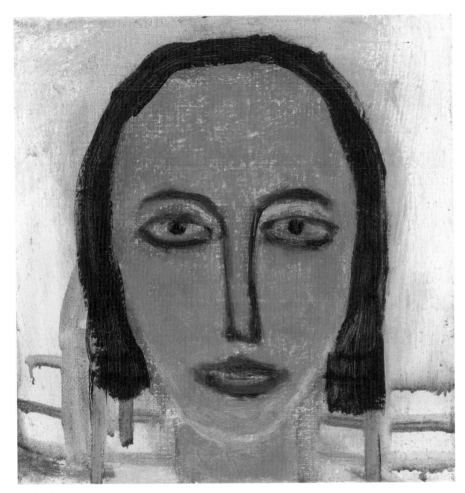

Study H.I. 2000

the gradual shift from the stimulus of outer event to that of inner
impulse. Just as historical considerations account for but part of the
poetic magic that is a film by Tarkovsky, so does the art of Andrzej
Jackowski resonate far beyond matters of history, no matter how
constitutive or critical in nature such matters may be. And such is
the potency of this art, that matters of personal biography acquire
a resonance which takes them many a fortunate mile from that
dispiriting narcissism which has marred a good deal of recent, self-
obsessed contemporary art.

To speak of the poetic dimension in Jackowski might once have
been to speak of an epic dimension commensurate with the imposing
size of such works as *Settlement*, 1986, *Earth-stepper with Running Hare*, 1987,
or *The Beekeeper's Son*, 1991. However, it takes but a moment's reflection to
recall that, like so much of Jackowski's early work, these pieces project
a great deal of intimacy, as tender in nuanced affect as those pieces are
thoroughly realised as paintings. What has happened recently is that,
while the work has decreased considerably in size, the poetic scale of the

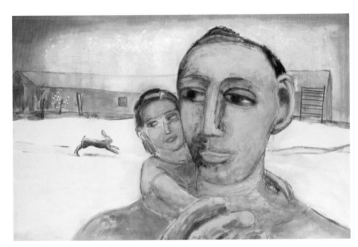

Earth-stepper with Running Hare 1987

imagery remains considerable in impact, as a taut yet openly conceived lyricism deploys a long-developed sophistication of distilled means.

The poetic strength of Jackowski's work is such that this painter is often able to intimate, or summon, what psychologists call the terrain of the transpersonal. This is the world of Rilke's gradually emerging "legends"; of those testing but ultimately energising archetypes of psychic growth encountered in the realm that the shamans (or healing visionaries) of old explored as they wandered deep into the Underworld, ascended the Tree of Life or flew high into the celestial realm, in order to attain the synoptic vision and wisdom that would help those shamans sustain the health of their tribe; that would strengthen the *anima*—or soul—of both the individual and the wider community.[15]

Just as it was appropriate that Jackowski participated in the 1989 South Bank, London show *The Tree of Life: New Images of an Ancient Symbol*, it felt only natural to me to include a consideration of Jackowski's work in my 1992 publication *Dreaming With Open Eyes: The Shamanic Spirit in Twentieth Century Art and Culture*.[16] Jackowski's work has long made the old new, long drawn inspiration from the deepest of sources: the artist has often spoken positively of the relation of both Tantric ideas and shamanism to painting, referring to his work as "archaic fiction", or stepping stones to the inner ground—"where the stories come from", as Bruno Schulz has put it. And while much of Jackowski's work is centred, and refreshingly so, on the female figure, the question of *anima*, or soul, is central to all his work.[17]

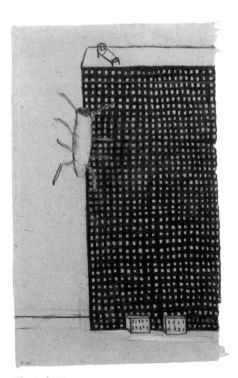

The Early Hours 2007

Station 2004

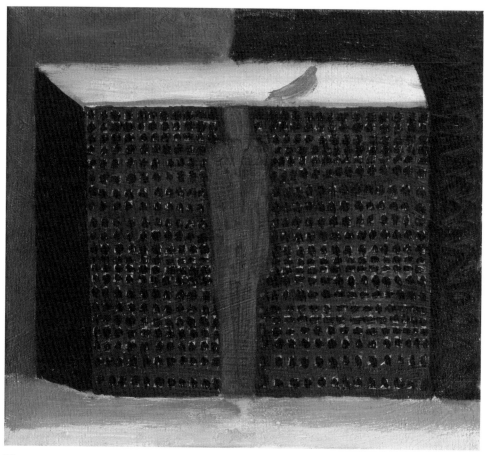

Hive 2004

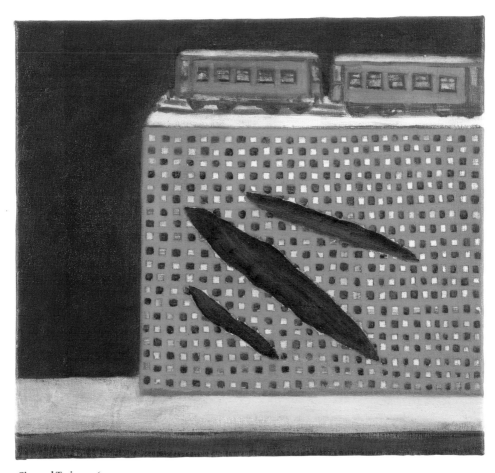

City and Train 2006

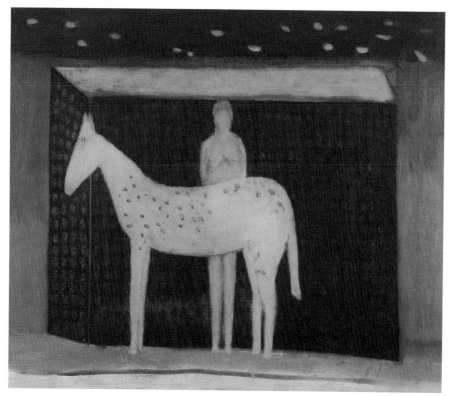

Hive II 2004

Painted on a half-chalk ground, scraped and sanded, rubbed and glazed, Jackowski's images seem to light themselves from far within, as they come to speak of matters that reside equally deep in the human psyche. One does not have to be familiar with such a shamanic trope as the idea of animal or spirit helpers in order to respond to such memorable recent paintings as *On the Edge* or *Vigilant Fox*. However, the primitivistic aura of such work, with its seemingly slightly awkward figuration bodied forth by what is actually a highly literate and sophisticated combination of drawing and design, colour and handling, has an imaginal, even musical, force which undoubtedly belongs to the shamanic domain.[18]

As the late historian of religions Mircea Eliade suggested in a variety of works, including his classic study *Shamanism: Archaic Techniques of Ecstasy*, the transfiguring potential of poetic creativity is crucial both to the aboriginal shamanic world view and the current evolutionary health of the human soul and imagination.[19] It is exactly this (primal yet evolving) potential which distinguishes the lyrically wrought art of Andrzej Jackowski: which gives the fullest—shamanic—weight to the idea that, whether epic or lyric in scope, this painter is indeed a poet, of rare and soulful consequence.

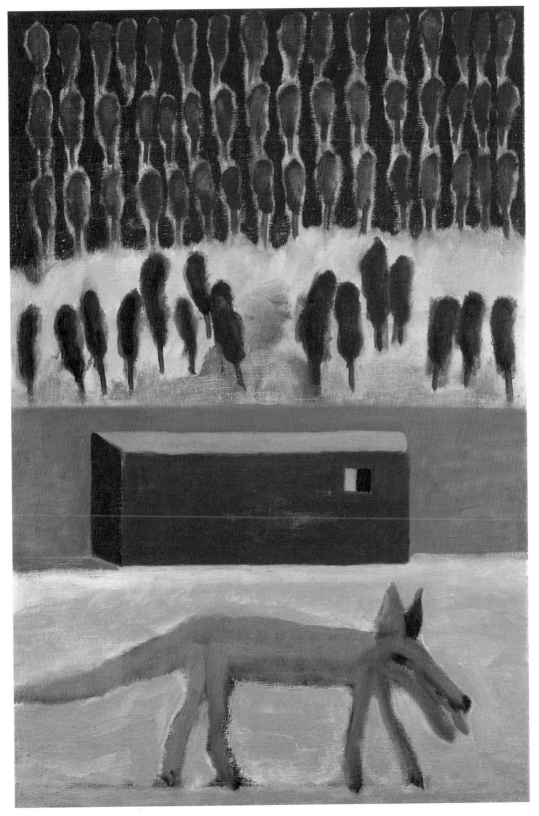

Vigilant Fox 2009

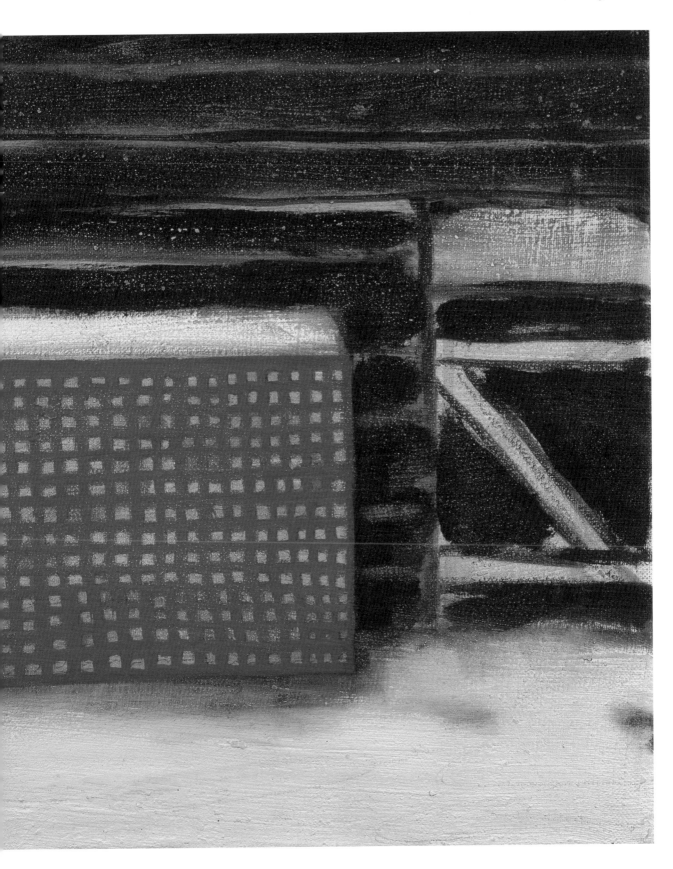

Study for cells, from a sourcebook, 2004.

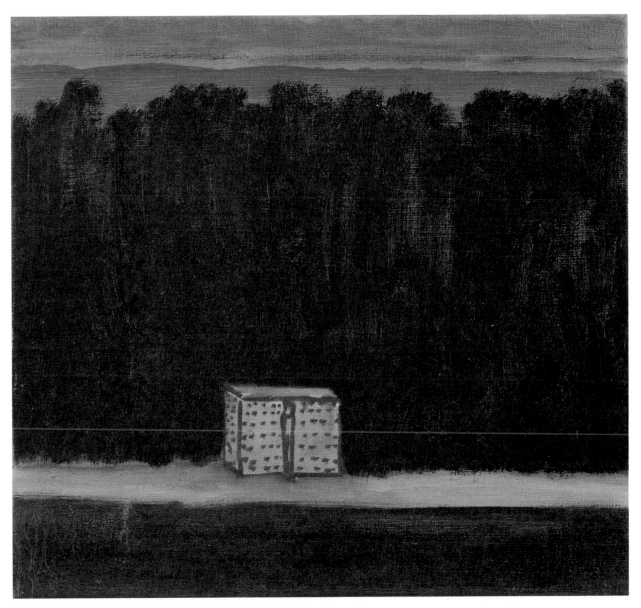

At the Lining 2005

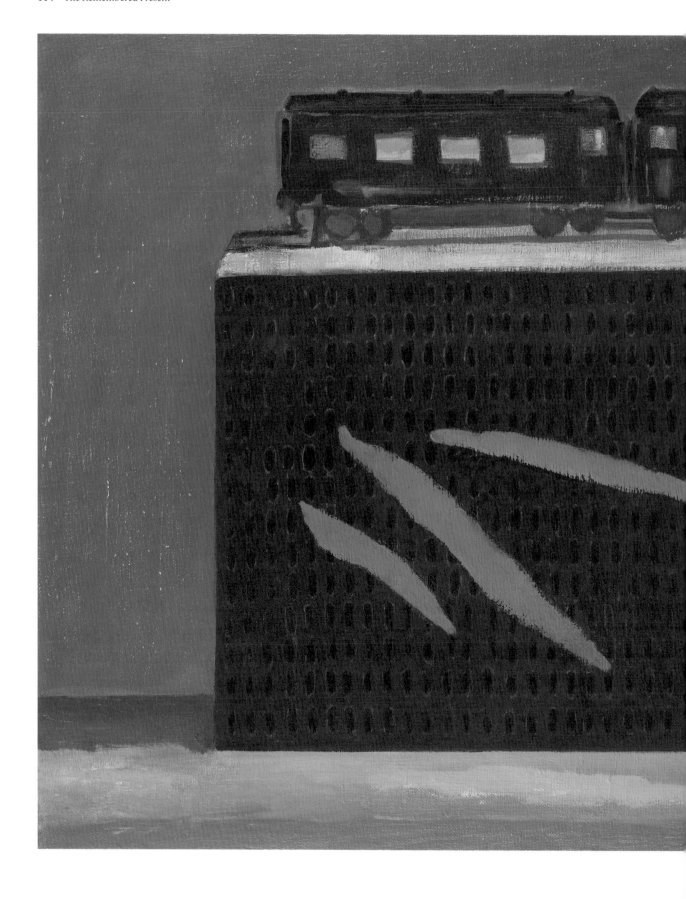

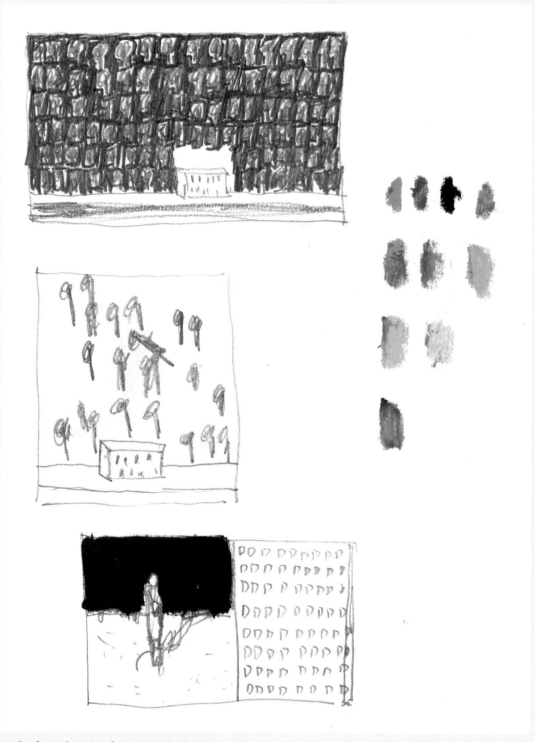

Studies for At the Lining, from a sourcebook, 2005.

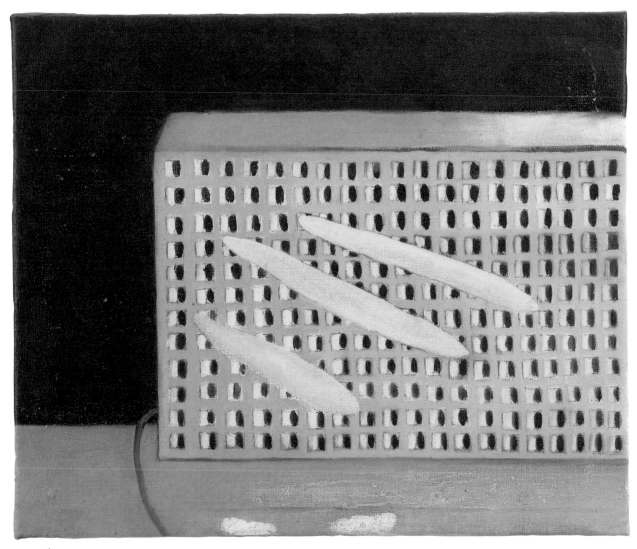

Sanatorium 2006

The Patient Hive 2005

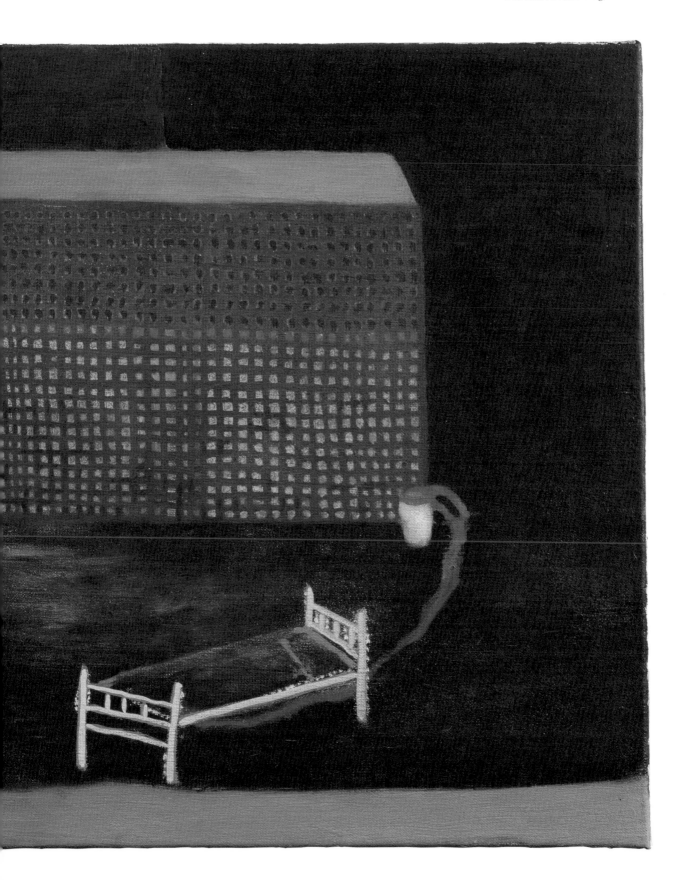

Study for Dream, from a sourcebook, c. 2006.

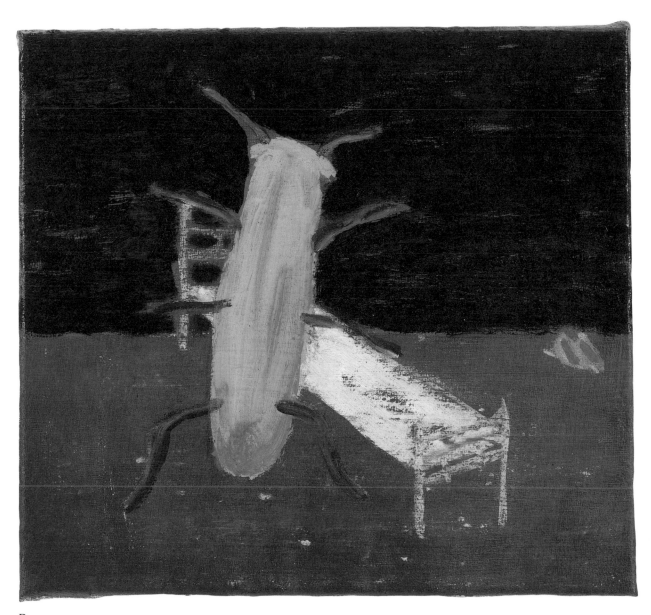

Dream 2007

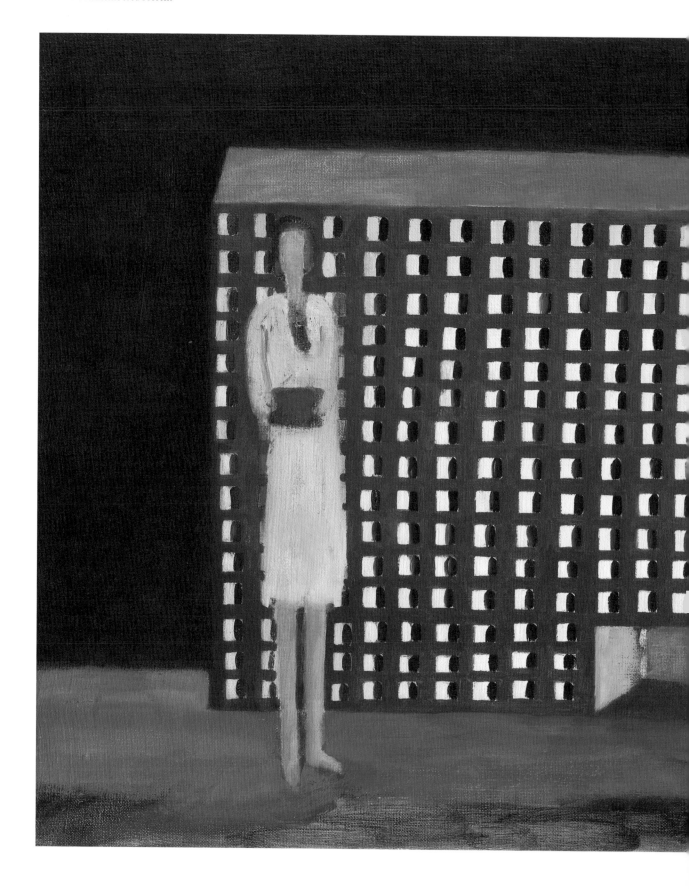

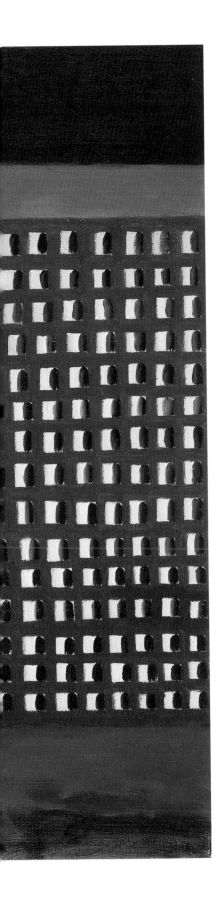

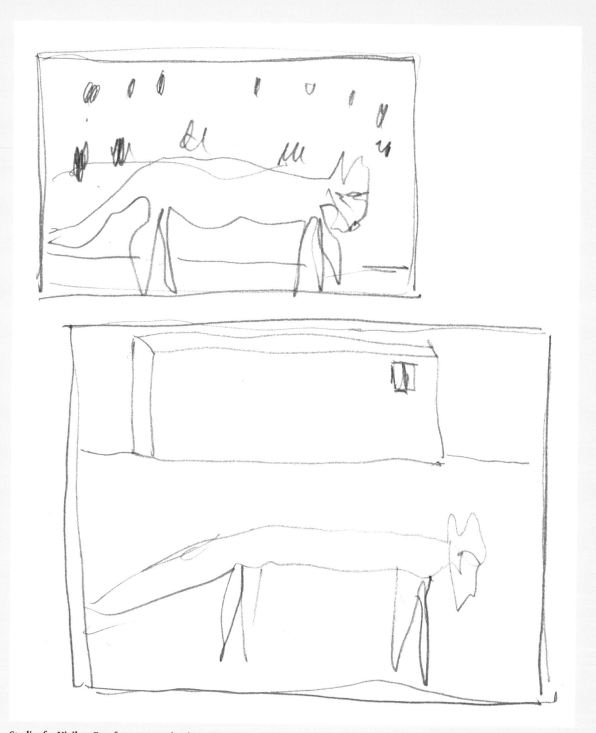

Studies for Vigilant Fox, from a sourcebook, c. 2005.

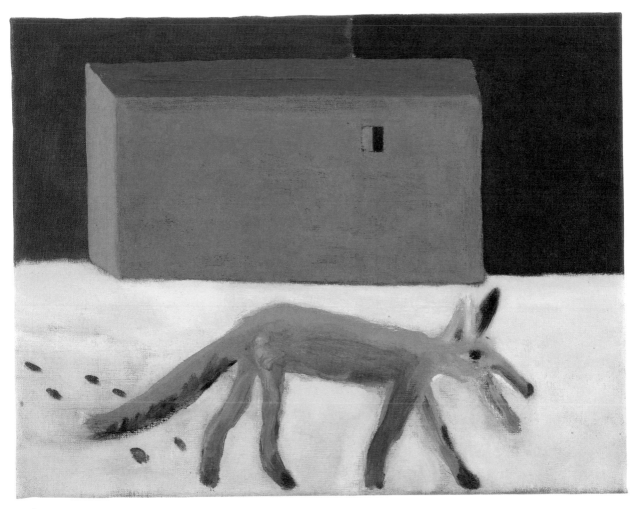

Vigilant Fox 2007

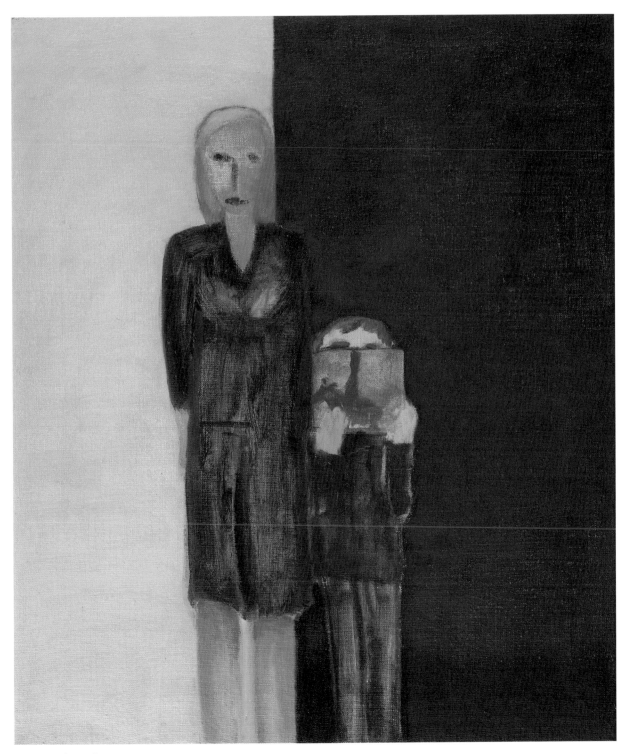

A Space in the Dark 2009

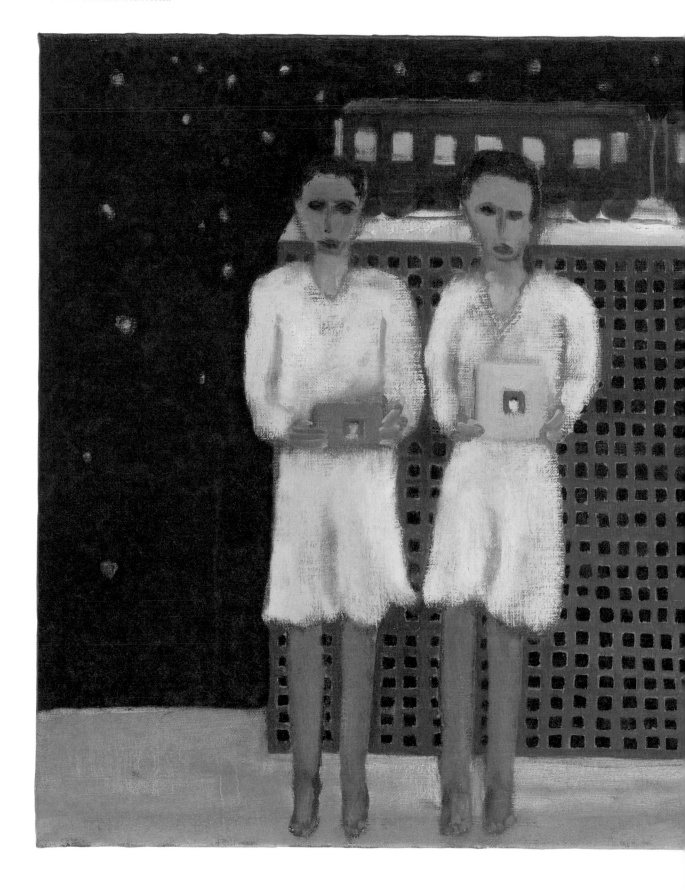

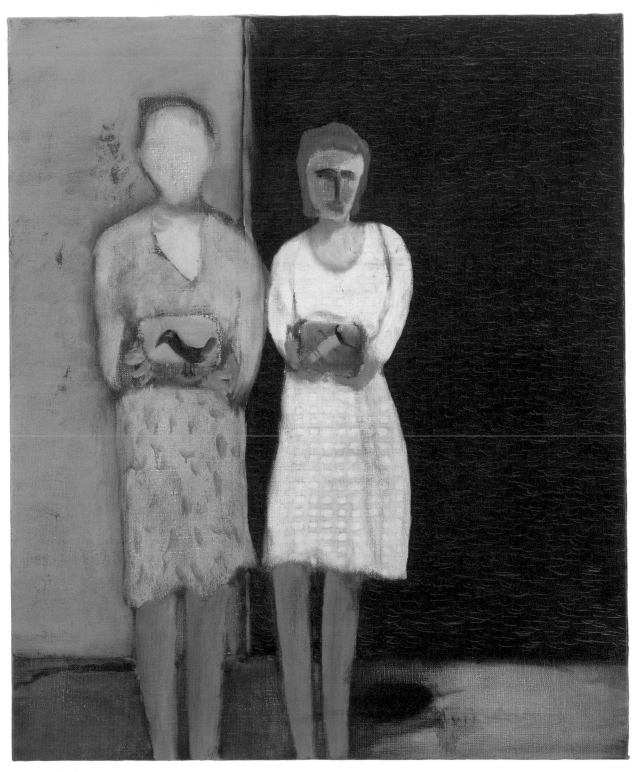

Sisters with Albums 2007

Child with Shadow 2009

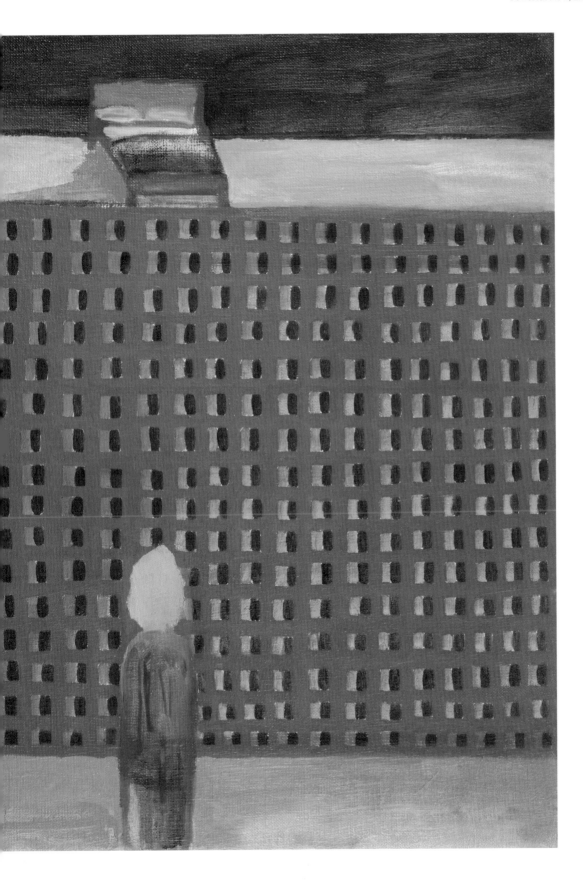

Studies for Vigilant Dreamers, from a sourcebook, 2008.

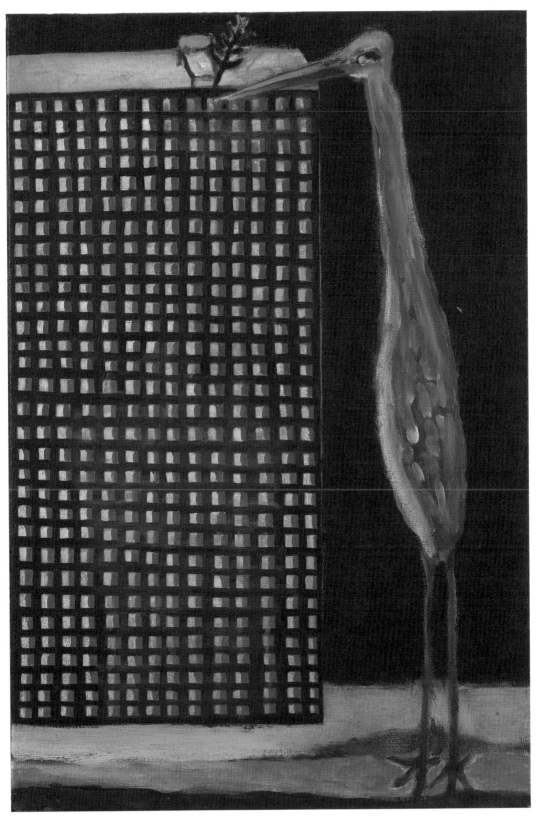

Vigilant Dreamer II 2009

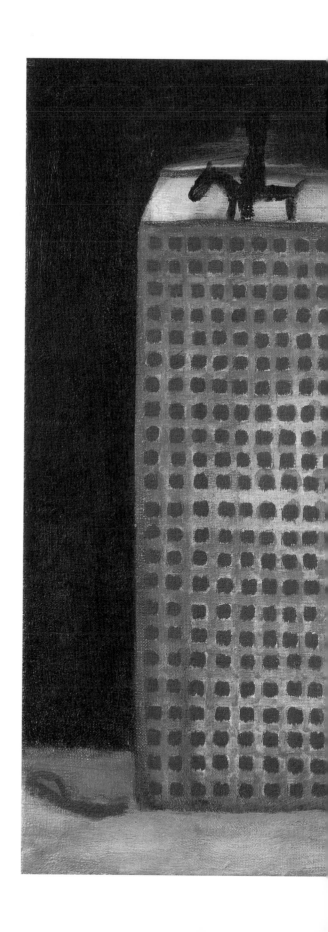

Vigilant Dreamer 2009

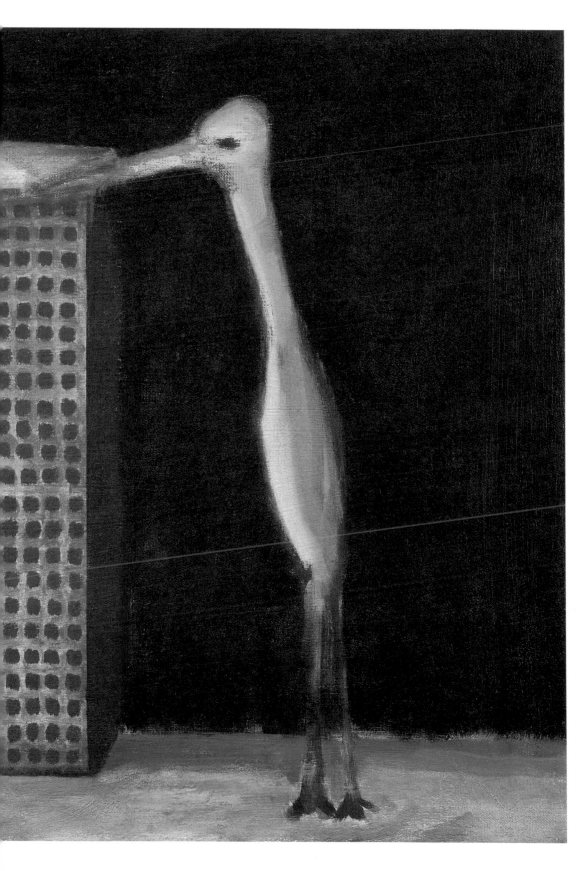

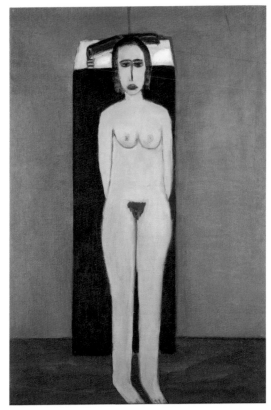

Woman with Train 2009

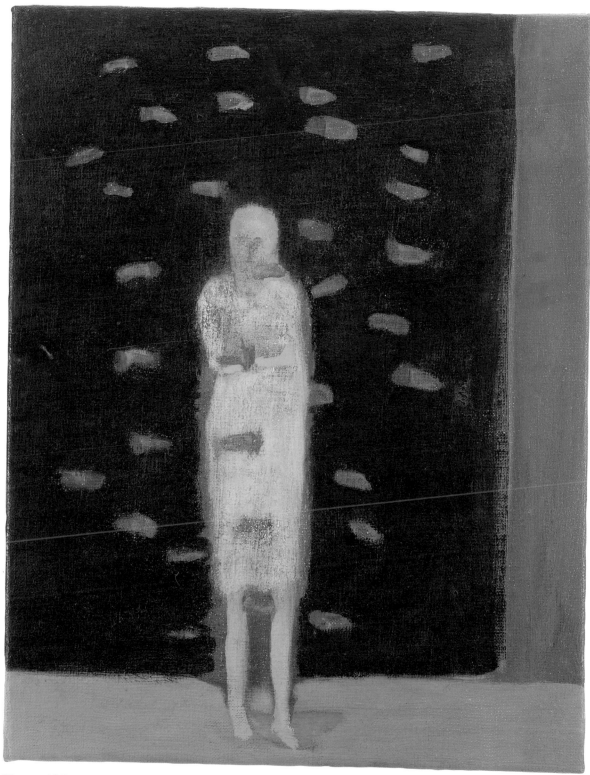

Woman with Bees 2007

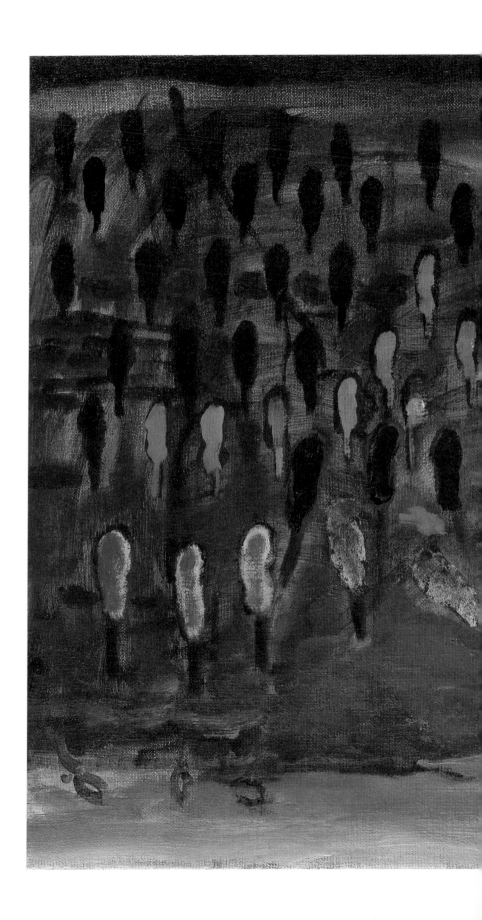

On the Edge 2009

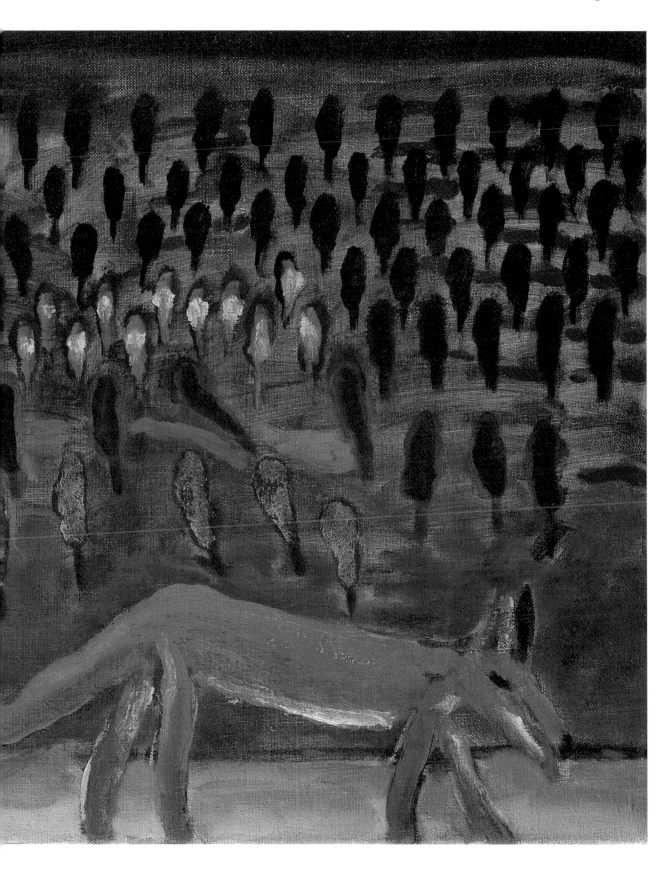

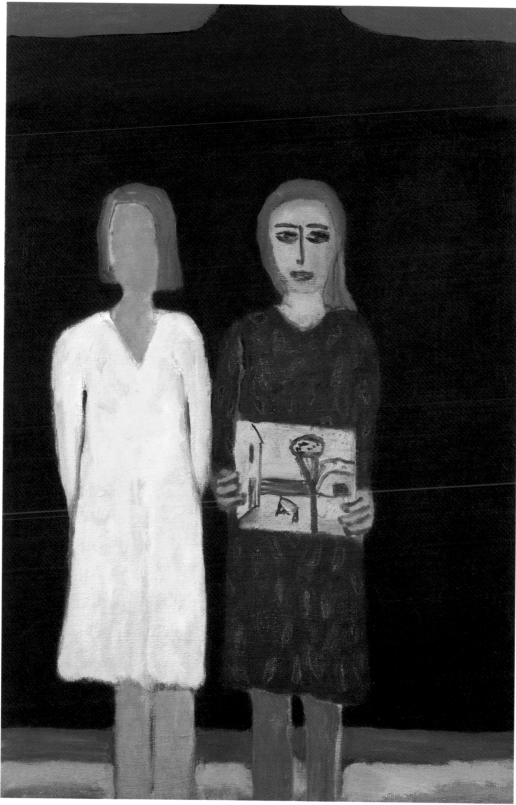

The Remembered Present 2009

The Pine Tree by the Sea
Andrzej Jackowski

In 1976, while a student at the Royal College of Art, I made a small etching; a kind of self-portrait: looking longingly out of my domestic space, past the marital bed (in the mirror) the pram and the dark shadows of discord. In the picture is another picture; Carlo Carrà's *The Pine Tree by the Sea*. I have looked at Carrà's picture ever since.

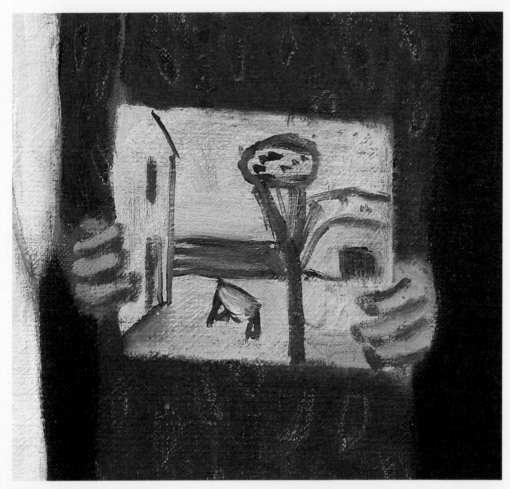

The Remembered Present (detail) 2009

This is a space for dreaming;
A space of a life.
In the House of Love,
I move around the dark spaces,
Opening doors
I climb the stairs, sifting the
Childhood of the shadows

By the deep sea's edge,
The warm ochres and pinks
Warm and replenish me.
There is no boat or jetty
To take me
Out to sea… which flows
Into a dark hole of a cave,
Like a fairground entrance
To the Ride of Death.

From the beginning,
The couple that live in this house
Like to spend their days
Day-dreaming
Playing games,
Enjoying
Domestic rituals
(Mondays and Wednesdays;
Washing of Animals)
And engineering
Intimate cities
To explore.

Some days they are at a loss; the dark sea of concealed life moves in
and floods the ground under them. Their understanding falls, as they
winter in their last journey.

The tree growing rich erect,
Stands in the remembered present;
Folding me in.

End Matter
Notes, Works, Biography,
Contributors and Acknowledgements

Notes

Retrieving a New Poetics of Space, 1980–1990

1 Jackowski, in *Albums & Aliens*, London: Purdy Hicks Gallery, 1997.
2 Jackowski, *Albums & Aliens*, 1997.
3 Jackowski, in conversation with the author, August 2002.
4 Josipovici, Gabriel, "A Conversation with Andrzej Jackowski", *Modern Painters*, Spring 2001.
5 Josipovici, *Modern Painters*.
6 Jackowski interviewed by Timothy Hyman, *Third Ear*, Radio 3, 1991.
7 Jackowski, *Third Ear*.
8 Jackowski in conversation with Timothy Hyman, December 1988 London: Marlborough Fine Art, 1989.
9 Jackowski, *Third Ear*.
10 Jackowski, Marlborough Fine Art, 1989; Tantra was classed, in terms of Indian tradition, as a "left-hand path", avoiding the Brahmanical mainstream.
11 Rawson had already published his book *Drawing*, Oxford University Press, 1969, arguably the best analytical text on the subject ever written.
12 Dubuffet, quoted by Jackowski in 11.32 Royal College of Art, 1977.
13 Jackowski, Marlborough Fine Art, 1989 (I have added a phrase from the Radio 3 interview of 1991).
14 Jackowski, quoted by Timothy Hyman Liverpool, The Bluecoat Gallery, 1982–1983.
15 Jackowski to Gabriel Josipovici in *Modern Painters*.
16 Jackowski, letter to the author, 3 June 1979.
17 Grodeck, the unorthodox psychoanalyst and author of *The Book of the It*, appealed to Jackowski partly for his ideas about the meaning of illness. "He believed that we speak with our illness as well as with our dreams, jokes, etc.." (Letter to the author, 8 February 1985).
18 Jackowski, note on *The Tower of Copernicus*, 1980.
19 Jackowski, note on *The Tower of Copernicus*, 1980.
20 Jackowski, *Third Ear*.
21 Jackowski, note on *The Tower of Copernicus*, 1980.
22 Jackowski, in conversation with the author, August 2002.
23 Jackowski, note on *The Tower of Copernicus*, 1980.
24 Berger, John, in *New Society*, 23 June 1983.
25 Jackowski to Gabriel Josipovici in *Modern Painters*.
26 Jackowski to Gabriel Josipovici in *Modern Painters*.
27 Jackowski, *Third Ear*.
28 Jackowski, Marlborough Fine Art, 1989.
29 Jackowski in a lecture, 2002.
30 Tim Hilton, "Painting from Never Neverland", *The Guardian*, 23 October 1991. Hilton was closely identified with the American-influenced abstract painters of Stockwell Depot, so prominent in the 1970s; he'd found it impossible to accept the refigured painting of the 1980s.
31 Jackowski, Marlborough Fine Art, 1989.
32 Josipovici, Gabriel, Introduction to *Reveries of Dispossession*, London: Purdy Hicks Gallery, 1994.
33 Overy, Paul, 'Baltic Lyricism', *Studio International*, Autumn 1986.
34 Jackowski, *Third Ear*.
35 Josipovici, Gabriel in *Modern Painters*.
36 Jackowski has fantasised that a dance troupe of the Bausch kind might one day employ one of his images as a starting point.
37 Jackowski, in conversation with the author, August 2002.

Powerful Now, Like Legends

1 "Introduction" in *Andrzej Jackowski: Oil Paintings*, London: Marlborough Fine Art, 1986, p. 4.
2 "Depth Charges" in *Andrzej Jackowski*, London: Purdy Hicks Gallery 2005 p. 13.
3 Quoted on back jacket of *Vuillard*, Montreal & Washington, New Haven & London: Yale University Press, 2003. See Skelton, R *Poetic Truth*, London: Heinemann Educational Books, 1978, for formal and philosophical justification of the claim (p. 116) that "[...] Poetry does present itself as a kind of judgement of all other and more approximate modes of communication and decision [...]".
4 McEwen, 2005, p. 8.
5 Compare e.g. the dream-charged 'void' paintings which Joan Miró made in the mid-1920s with the mid-1930s work of Salvador Dalí or the later work of Max Ernst and Leonora Carrington.
6 See Tucker, M, *Dreaming With Open Eyes: The Shamanic Spirit in Twentieth-Century Art and Culture*, London & San Francisco: Aquarian/ HarperCollins, 1992, p. 333.
7 Lynton, p. 4.
8 McEwen, p. 11.
9 See Tucker, pp. 181 & 136–139. Ekelöf's art criticism is collected in Moberg, U T, *Gunnar Ekelöf skriver om konst*, Stockholm: Cinclus Press, 1984. For Ekelöf in English translation, see *Selected Poems of Gunnar Ekelöf*, trans. Muriel Rukeyser & Leif Sjöberg, New York: Twayne Publishers 1967 and *Modus Vivendi: Selected Prose By Gunnar Ekelöf*, ed. & trans. Eric Thygesen, Norwich: The Norvik Press, 1996.
10 See Gaudin, C, (ed.) *Gaston Bachelard: On Poetic Imagination and Reverie*, Dallas: Spring Publications 1987 and (on Joyce) Tucker, pp. 333–334.
11 "In Conversation with Timothy Hyman, December 1988" in *Andrzej Jackowski: The Brides and Other Paintings*, London: Marlborough Fine Art, 1989, p. 8.
12 "It is above all through time and sense of rhythm that the director reveals his individuality." Tarkovsky, *A Sculpting In Time: Reflections on the Cinema*, London: Faber and Faber, 1989, p. 120; see Tucker, pp. 260–263.
13 "History 'In The Next Room'" in *Andrzej Jackowski: A Drawing Retrospective*, Brighton & London: University of Brighton/Purdy Hicks Gallery, p. 23.
14 See e.g. "Report From Paradise" in *Zbigniew Herbert: Selected Poems*, trans. Czeslaw Milosz & Peter Dale Scott, Harmondsworth: Penguin Books, 1968, p. 131 and "Sometimes We Are Tied Down…" in *The Selected Poetry of Jaroslav Seifert*, trans. Ewald Osers & George Gibian, London: Andre Deutsch, 1986, p. 54. (See also Milosz, C, ed. *Postwar Polish Poetry*, Berkeley: University of California

Press 1983.) The larger poetic resonance in Jackowski's recent images of cellular building structures, which the artist himself sees in terms of "love cells" or "hives" rather than high-rise apartments or tower blocks, was anticipated in Peter Redgrove's "Guarded By Bees" from the 1979 collection *The Weddings at Nether Powers*: a curious and happy coincidence, this, for while Redgrove was an important figure for Jackowski's early development, he did not know of this poem until I showed it to him in March 2009. See Redgrove, P, *The Moon Disposes: Poems 1954–1987*, London: Secker & Warburg, 1987, pp. 124–125, including the wonderful line "This would be my euthanasia, to be stung by sweetness".

15 For an overview of the phenomenology and symbolism of shamanism, see Tucker, pp. 76–99, ch. 4 "Call of the Shaman". While such relatively broad-brush considerations can help us grasp the wider import of Jackowski's poetics, one should remember that, for this artist, whatever ideas might be intuited as underpinning the work, the work itself must body forth whatever meaning we may wish to ascribe to it. One particular aspect of Jackowski's art merits emphasis here: namely, the play of form and detail in the work, the extent to which the artist never gets lost in, or overdoes, matters of either detail or "finish". Hence the breathing, open-ended quality in much of the work: as van Gogh is said to have remarked, "*Trop de détails effacent la rêverie.*"

16 Tucker, pp. 332–333 (including b&w illustration of *Earth-Stepper with Running Hare*). See *The Tree of Life: New Images of an Ancient Symbol*, London: South Bank Centre, 1989, p. 35 for colour reproduction of Jackowski's featured *Walking to the River*, 1988.

17 It is instructive to compare the latent potency of Jackowski's quietly stilled approach to the female figure with some of the more aggressively pitched material in the 2005 show and catalogue *La dona, metamorfosi de la modernitat*, Barcelona: Fundació Joan Miró 2005 (with English texts). On notions of *anima*, soul and spirit and "thinking with the heart" see Tucker 1992; Hillman, J, *Anima: An Anatomy of a Personified Notion*, Dallas: Spring Publications 1985, and Hillman, J, *The Thought of the Heart*, Dallas: Eranos Lectures 2 Spring Publications 1987.

18 The musical quality in much of Jackowski's work finds complementary parallel in the fact that some of the best Polish jazz of recent decades has a strikingly lyrical, mytho-poetic pictorial quality. See e.g. the late pianist Krysztof Komeda's *Crazy Girl*, Power Bros PB 00145—which features Komeda's early-1960s score for filmmaker Roman Polanski's *Knife In The Water*—and trumpeter Tomasz Stanko's 2005 recording *Lontano*, ECM 1980. Stanko's Polish quartet can be seen recording the beginning of 'Lontano III', an especially affecting free ballad example of Slavic soul, in chapter 10, 'The Personal Signature', of Julian Benedikt's 2006 film *Play Your Own Thing: A Story Of Jazz In Europe*, EuroArts 2055748. This features voice-over commentary (in English) by the esteemed Norwegian saxophonist Jan Garbarek—whose father was Polish. See Tucker, M, *Jan Garbarek: Deep Song*, Hull: Eastnote/Hull University Press, 1998.

19 See Eliade, M, *Images And Symbols: Studies In Religious Symbolism*, Princeton: Princeton University Press 1991 (where the factor of creative spiritual spontaneity is emphasised: see p. 122); Eliade, M, "The Sacred and the Modern Artist", Chicago: University of Chicago, Divinity School *Criterion* 1965 vol 4 part 2; and Eliade, M, *Shamanism: Archaic Techniques of Ecstasy*, Princeton: Bollingen Series/Princeton University Press 1974, especially pp. 508–511 "Epilogue": "Poetic creation still remains an act of perfect spiritual freedom. Poetry remakes and prolongs language; every poetic language begins by being a secret language, that is, the creation of a personal universe, of a completely closed world. The purest poetic act seems to re-create language from an inner experience that, like the ecstasy or the religious inspiration of 'primitives', reveals the essence of things."

Works

Page 10
School Drawing 3 1963
pastel on paper, 9.5 x 14 cm

Page 11
The Wooden Vessel 1983
oil on canvas, 167.5 x 152.5 cm

Page 13
Room with a View 1975
mixed media on paper, 21 x 26 cm

Page 15
Love's Journey I 1983
oil on canvas, 166 x 152.5 cm

Page 16
The Fir Tree 1983
oil on canvas, 152.5 x 182.5 cm
Harris Museum & Art Gallery, Preston

Page 18
The Vigilant Dreamer II 1985
oil on canvas, 182.5 x 152.5 cm

Page 19
The Visit 1977
pencil on paper, 16 x 15 cm

Page 20
Rudolph Steiner 1979
mixed media on paper, 39 x 28.5 cm

Page 21
Surfacing 1987
oil on canvas, 163 x 183 cm

**Dr. Grodeck in his Clinic
in Baden-Baden** 1979
oil on canvas, 147 x 112 cm

Page 22
Diving into the Wreck 1983
oil on canvas, 152.5 x 182.5 cm

Page 23
The Tower of Copernicus 1980
oil on canvas, 136.6 x 117 cm
Arts Council Collection,
Hayward Gallery, London

Page 24
The Black Bride 1986
oil on canvas, 152.5 x 132 cm

Page 25
Downfalling 1982
oil on canvas, 167.5 x 152.5 cm
South East Arts, Towner, Eastbourne

Page 26
Settlement 1986
oil on canvas, 152.5 x 233.5 cm
Arts Council Collection,
Hayward Gallery, London

Page 28
Bower 1987
oil on canvas, 162.5 x 182.9 cm

Page 30
The Beekeeper's Son 1991
oil on canvas, 168.3 x 233.7 cm
Walker Art Gallery, National Museums
and Galleries on Merseyside

Page 32
Hive 1989
oil on canvas, 198.1 x 243.8 cm

Page 33
Beginning the Game 1991
oil on canvas, 60.5 x 91.5 cm

Dove 1996
oil on canvas, 152.4 x 233.8 cm

Page 34
Settling in Drift 1990
oil on canvas, 152.4 x 233.8 cm

Page 37
Dreaming Earth 1987
oil on canvas, 152.5 x 132 cm
Ferens Art Gallery, Hull

Page 38
Settlement with Three Towers 1986
oil on canvas, 152.5 x 233.5 cm

Page 41
Umbrella Tree 1988
oil on canvas, 152.5 x 142 cm

Page 42
Plans for the City 1989
oil on canvas, 152.4 x 233.8 cm

Page 49
Refuge/Refugee 1982
oil on canvas, 137.2 x 122 cm

Page 50
The Boy Who Broke the Spell 1996
oil on canvas, 152.4 x 162.5 cm
Aberdeen Art Gallery and
Museums Collections

Page 51
**Study for The Tower
of Copernicus** 1980
pencil on paper, 19 x 16 cm

Page 52
The Covered Table 1994
oil on canvas, 152.4 x 162.5 cm

Page 54
At the Lining of Things 1991
oil on canvas, 152.4 x 142.2 cm

**The Tower of Copernicus
– Autumn** 1982
oil on canvas, 152.5 x 132 cm

Page 55
**The Tower of Copernicus
– Winter** 1982
oil on canvas, 152.5 x 132 cm

Page 56
The Burying 1994
oil on canvas, 152.4 x 162.5 cm

Page 57
Hide and Seek 1994
oil on canvas, 152.4 x 162.5 cm

Page 58
Mother and Son 1999
oil on canvas, 142.2 x 182.9 cm

Page 60
Figure with Small Garden 2001
oil on canvas, 142.7 x 183 cm

Page 61
Standing Train 1997
oil on canvas, 142.2 x 152.4 cm

Tearing Apart 1994
oil on canvas, 152.4 x 162.5 cm

Page 62
A Child in the Dark 1992
oil on canvas, 152.4 x 162.6 cm

Page 64
Father and Son II 1999
oil on canvas, 152.4 x 182.9 cm

Page 66
Father and Son III 1999
oil on canvas, 152.4 x 193 cm

Page 69
Two Narrow Beds 1999
oil on canvas, 152.4 x 193 cm
Deutsche Bank

Page 70
Family 2001
oil on canvas, 142.5 x 183 cm

Page 73
Family Wardrobe 2001
oil on canvas, 152.5 x 183 cm

Page 74
The Assistant 1995
mixed media on paper, 56 x 42 cm
Deutsche Bank

Page 75
The Assistant II 1996
mixed media on paper, 52 x 41 cm
Deutsche Bank

Page 76
The Laboratory Assistant 1994
oil on canvas, 152.4 x 162.5 cm

Page 79
Hearing Voices III 1993
oil on canvas, 152.4 x 162.5 cm

Page 80
Beneath the Tree 1994
oil on canvas, 152.4 x 162.5 cm
University of Warwick

Page 82
Curing Fruit 1996
oil on canvas, 152.4 x 162.5 cm

Page 85
Standing Figure 1997
oil on canvas, 152.4 x 142.4 cm

Page 86
Bird 2008
mixed media on paper, 27.5 x 41 cm

Page 90
The Early Hours II 2007
charcoal and wax crayon on paper,
82 x 52 cm

Page 91
The Voyage 2003
etching, 39 x 43 cm edition of 10

The Lesson 2005
oil on canvas, 40.5 x 55 cm

Page 92
A Space in the Dark 2007
oil on canvas, 49.5 x 53 cm

Page 93
Dwelling 2007
oil on canvas, 45 x 48 cm

Page 94
Woman with Bees 2009
oil on canvas, 70 x 60 cm

Page 95
Woman with Tree 2009
oil on canvas, 82.5 x 55 cm

Page 97
Sanatorium II 2007 oil
on canvas, 44 x 52 cm

Page 98
Night Cells 2005
oil on canvas, 44 x 52 cm

Page 99
Breath-Space 1987
oil on canvas, 142 x 152.5 cm

Horse I 2004
mixed media on paper, 38 x 54 cm

Page 100
Love Cells 2005
oil on canvas, 45 x 48 cm

Page 102
Study H.I. 2000
oil on canvas, 25.4 x 25.4 cm

Page 103
Earth-stepper with Running Hare
1987 oil on canvas, 152.4 x 233.7 cm
Deutsche Bank

The Early Hours 2007
charcoal and wax crayon on paper,
82 x 52 cm

Page 104
Station 2004
oil on canvas, 40.5 x 51 cm

Page 106
Hive 2004
oil on canvas, 32.5 x 36 cm

Page 107
City and Train 2006
oil on canvas, 49 x 55 cm

Page 108
Hive II 2004
oil on canvas, 60 x 70 cm

Page 109
Vigilant Fox 2009
oil on canvas, 83 x 55 cm

Page 110
Fate 2004
oil on canvas, 40.5 x 44 cm

Page 113
At the Lining 2005
oil on canvas, 49 x 53 cm

Page 114
City and Train 2009
oil on canvas, 60 x 70 cm

Page 117
Sanatorium 2006
oil on canvas, 46 x 56 cm

Page 118
The Patient Hive 2005
oil on canvas, 60 x 70 cm

Page 121
Dream 2007
oil on canvas, 32.5 x 36 cm

Page 122
Love Cells 2009
oil on canvas, 60 x 70 cm

Page 125
Vigilant Fox 2007
oil on canvas, 45 x 59 cm

Page 127
A Space in the Dark 2009
oil on canvas, 70 x 60 cm

Page 128
Sisters with Albums and Train 2007
oil on canvas, 60 x 70 cm

Page 131
Sisters with Albums 2007
oil on canvas, 70 x 60 cm

Page 132
Child with Shadow 2009
oil on canvas, 60 x 70 cm

Page 135
Vigilant Dreamer II 2009
oil on canvas, 82 x 55 cm

Page 136
Vigilant Dreamer 2009
oil on canvas, 60 x 70 cm

Page 138
Woman with Train 2009
oil on canvas, 82.5 x 55 cm

Page 139
Woman with Bees 2007
oil on canvas, 51.4 x 41 cm

Page 140
On the Edge 2009
oil on canvas, 55 x 82.5 cm

Page 143
The Remembered Present 2009
oil on canvas, 82.5 x 55 cm

Page 144
The Remembered Present 2009
oil on canvas, 82.5 x 55 cm (detail)

Biography
The Visit 1979
oil on canvas, 147.5 x 117 cm

The Tower of Copernicus 1980
oil on canvas, 136.6 x 117 cm
Arts Council Collection,
Hayward Gallery, London

The Bride II 1986
Mixed media on paper, 40 x 35 cm

Study for At the Lining 2004
mixed media on paper, 52 x 51.5 cm

The Remembered Present 2009
etching and chine colle, 48 x 41.5 cm,
edition of 25

Biography
Andrzej Jackowski

1947–1958
Born to Polish parents in Penley
Hospital, North Wales. First 11 years
spent in Doddington Park Resettlement
Camp, in Cheshire, living in wooden
huts covered in tar. Father collects
Hungarian stamps.

1958–1968
Family move to London and live with
photographer half-brother.

Attends Holland Park School. Inspiring
art teacher, Judy Wade, encourages going
to art school. At Camberwell School
of Art is taught mainly in the 'dot-
and-carry' manner way of drawing by
tutors, including Euan Uglow.

1968–1974
At Falmouth School of Art finds it
difficult to paint as the main focus is
either the 'Camberwell dot-and-carry'
method or American abstract colour
field painting. Comes under the spell of
the poet Peter Redgrove; discovers poetry,
Surrealism and the unconscious. In

the second year starts making short
silent narrative films. Shows at the
Southampton Student Film Festival.
Asked to leave the course, as the staff
can't evaluate the films.

Marries the poet Nicki Tester. Together
form the 'The Tower of Babel' giving
multi-media poetry readings.

Daughter Laura born in 1972.

1974–1977
Returns to Falmouth School of Art to
finish the painting course. The external
assessor is Professor Peter de Francia
who encourages him to apply to the
Royal College of Art in London.

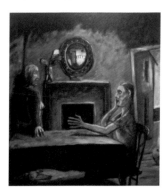

At the Royal College of Art meets RB Kitaj
whose work he has admired for several
years. Other tutors include Howard
Hodgkin, Philip Rawson and Donald
Hamilton-Fraser, who introduces him
to the films of Andrei Tarkovsky.

1977–1980
South East Arts Fellowship at the
University of Surrey. Spends 18 months
as artist in residence.

In 1979 Chosen by Timothy Hyman for
the seminal exhibition, *Narrative Painting*
which tours from the Arnolfini in Bristol
to the Institute of Contemporary Arts
in London. First solo exhibition with
Moira Kelly Fine Art, London.

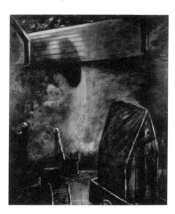

1980–1991
In 1980 paints *The Tower of Copernicus*
which wins one of the Tolly Cobbold
major prizes and is bought by the
Arts Council.

A touring exhibition from the Bluecoat
Gallery in Liverpool finishing at the
Anne Berthoud Gallery in London.

In 1986 has first of three exhibitions at
Marlborough Fine Art, London.

In 1991 wins first prize with his painting *The Beekeeper's Son* at the John Moores 22 Exhibition at the Walker Art Gallery in Liverpool.

Meets Eve Ashley (marries 1994). Two stepchildren, Catherine and Joe.

Son Louis born in 1990.

1991–2001
Begins a radical clearing out of his work. A new sparseness and paring down of the images begins.

In 1992 joins Purdy Hicks Gallery, London. *Reveries of Dispossession* exhibition tours to Brighton Museum & Art Gallery and the Ferens Art Gallery in Hull. First solo exhibition in Poland at the Kordegarda Gallery, National Gallery of Contemporary Art in Warsaw.

2001–2009
In 2003 starts working on a smaller scale in his paintings, with more stylised imagery.

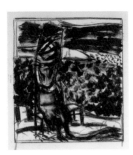

Drawing Retrospective 1963–2003 tours to University Gallery of Northumbria, Newcastle and the University of Brighton Gallery.

Artist in residence at Montserrat College of Art, Massachusetts, USA.

Made Professor of Painting in 2003 at the University of Brighton where he has been teaching part-time since 1987.

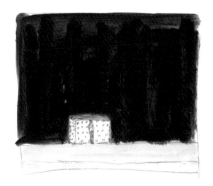

In 2008 first solo exhibition in New York at David Krut Projects.

In 2009 shows work from the last five years at Abbot Hall Art Gallery, Kendal, including a set of new prints *The Remembered Present*, a collaboration with the master printer Simon Marsh, who he has worked with on several projects since 1998.

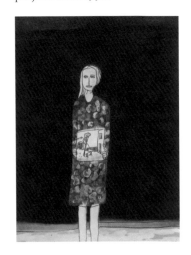

Images from left to right **Jackowski painting as a boy c. 1956;** *The Visit*, **1979;** *The Tower of Copernicus*, **1980;** *The Bride II*, **1986; Study for** *At the Lining*, **from a sourcebook, 2004;** *The Remembered Present*, **printed by Paupers Press, London, 2009.**

Contributors

Timothy Hyman is a painter and writer. In 1998 his widely praised monograph on Bonnard was published. In 2003 he published a book on Sienese Painting. Trained at the Slade he shows regularly with Austin/Desmond Gallery.

Gabriel Josipovici was born in France in 1940 and lived in Egypt from 1945–1956, when he came to this country. After reading English at Oxford he taught at the University of Sussex from 1963–1998. He is the author of 12 novels, three volumes of stories, numerous plays for stage and radio, and six critical works, ranging from a study of the Bible to essays on Kafka and Stockhausen.

Michael Tucker D Litt is Professor of Poetics at the University of Brighton. His many publications include material on the painters Alan Davie, Ian McKeever and Frans Widerberg and the poets Jan Erik Vold and Kenneth White, as well as on musicians associated with the ECM record label such as Jan Garbarek, Eberhard Weber and Jon Christensen. He has curated various exhibitions for the University of Brighton, including *Frans Widerberg: A Retrospective*, *Landscapes from a High Latitude: Icelandic Art 1909–1989*, *Alan Davie: Drawings* and *Dream Traces: A Celebration of Contemporary Australian Aboriginal Art*.

Acknowledgements

Andrzej Jackowski wishes to thank; Rebecca Hicks, Nicola Shane, Katy Barron, Jayne Purdy, Alistair Hicks, Duncan McCorquodale, Matt Bucknall, Tim Hyman, Gabriel Josipovici, Mike Tucker, Carol Dine, Simon Marsh, Chris Stevens, Janusz Delinikajtis, Eve Ashley, Catherine Bell and Louis Jackowski-Ashley.

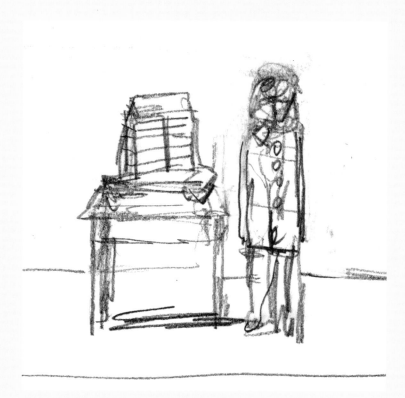

Study for Hearing Voices, c. 1992, from a sourcebook.

© 2009 Black Dog Publishing Limited, London, UK,
and the authors. All rights reserved.

Designed by Matt Bucknall at Black Dog Publishing.

Black Dog Publishing Limited
10A Acton Street
London WC1X 9NG
info@blackdogonline.com
www.blackdogonline.com

All opinions expressed within this publication are those of the
authors and not necessarily of the publisher.

British Library Cataloguing-in-Publication Data. A CIP record for
this book is available from the British Library.

ISBN 978 1 906155 88 9

Black Dog Publishing Limited, London, UK, is an environmentally
responsible company. *The Remembered Present* is set in Albertina
and printed on 170 gsm Arctic the Volume, an FSC certified paper.
SA-COC-001973.

Cover and essay introduction photographs taken at Andrzej Jackowski's
Brighton studio, June 2009. All photographs by Matt Bucknall/Black
Dog Publishing Limited.

Andrzej Jackowski childhood photographs by Janusz Delinikajtis.

architecture art design
fashion history photography
theory and things

**black dog
publishing**

www.blackdogonline.com

london uk